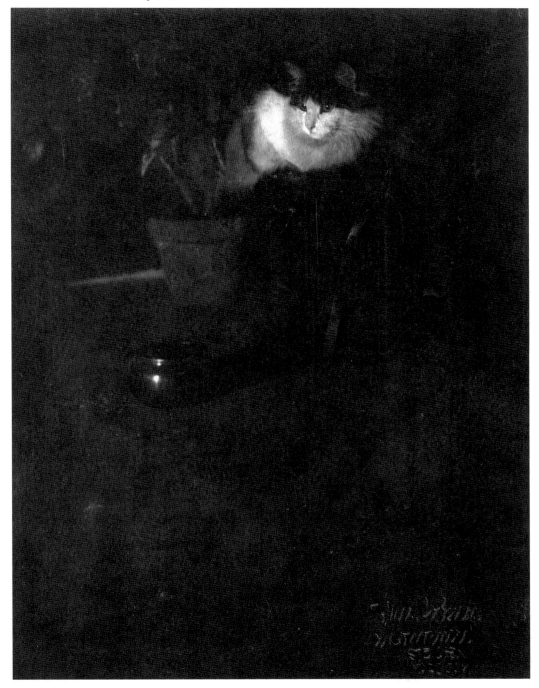

The CAT in Photography

SALLY EAUCLAIRE

A Bulfinch Press Book
LITTLE, BROWN AND COMPANY
Boston • Toronto • London

Library of Congress Cataloging-in-Publication Data
Euclaire, Sally.
 The cat in photography/Sally Euclaire. — 1st ed.
 p. cm.
 "A Bulfinch Press book."
 ISBN 0–8212–1782–8
 1. Photography of cats. I. Title.
TR729.C3E28 1990
779′.092 — dc20 90–31545
 CIP

Bulfinch Press is an imprint and trademark of Little,
Brown and Company (Inc.)
Published simultaneously in Canada by Little, Brown &
Company (Canada) Limited

PRINTED IN SINGAPORE

For

Isis and Siris Rumble-Thump,

and in memory of

Max Barkins, BazmaBoo, and Baron Bruno Bach,

who would have liked to help chase these cats

CONTENTS

PREFACE

*I*n the 1960s a cat fancier and prizewinning amateur photographer named Joseph R. Spies coined the word "catographers" to describe photographers of cats. As cute as the word seems, he had a point. Cats and photographers alike must be stealthy, patient, opportunistic, and curious.

The first photographers spent hours looking out windows, the favorite perch of cats. Later generations of camera enthusiasts would scramble over, under, beside, into, and out of everything imaginable, even if the location was off-limits, dangerous, or otherwise inconvenient. Inevitably, some got their own whiskers clipped or burned, a risk that their photographs suggest was well worth taking.

The photographs selected for publication here date from about 1850 to the present; they were discovered in museums, archives, studios, albums, and attics, and they comprise a variety of works by both world-famous professionals and unknown amateurs. Included are pictures by artists, photojournalists, commercial photographers, and even snapshooters. All of them share the cat's legendary psychic vision, without which they would have missed the subtle clues, correlations, and metaphors that tell not only of the charming, elegant, spooky, and tigerish ways of *Felis catus*, but of ourselves, our history, and our culture.

THE CAT IN PHOTOGRAPHY

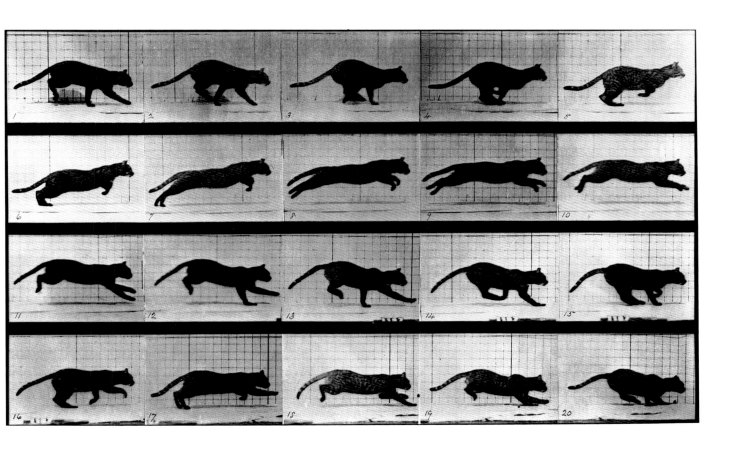

• 3 • Photographer unknown, Untitled, c. 1850

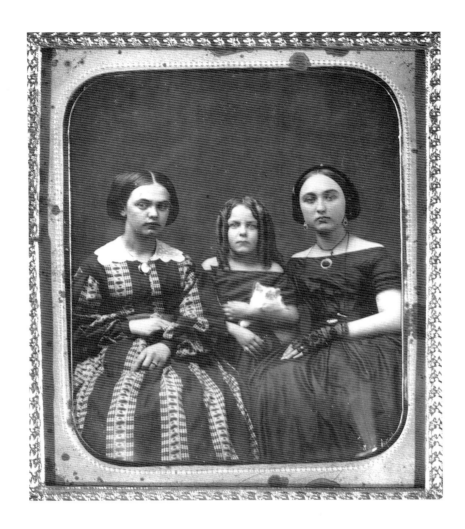

• 4 • Photographer unknown, Untitled, c. 1850

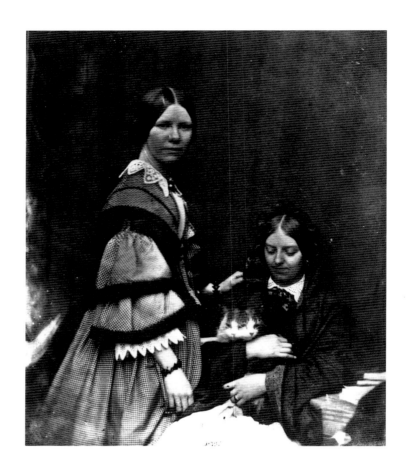

• 5 • Photographer unknown, *Mrs. Craik (and Sister?) Holding Cat*, n.d.

• 6 • THOMAS RICE BURNHAM, Untitled, c. 1860

•7• H. POINTER, Front and back of *carte de visite*, c. 1870

• 8 • Photographer unknown, Untitled, c. 1865

•9• CHARLES VICTOR HUGO and AUGUSTE VACQUERIE, *Vacquerie's Cat, Mouche*, c. 1853

•10• OSCAR GUSTAVE REJLANDER, *The Milkmaid Feeding the Cat*, 1855

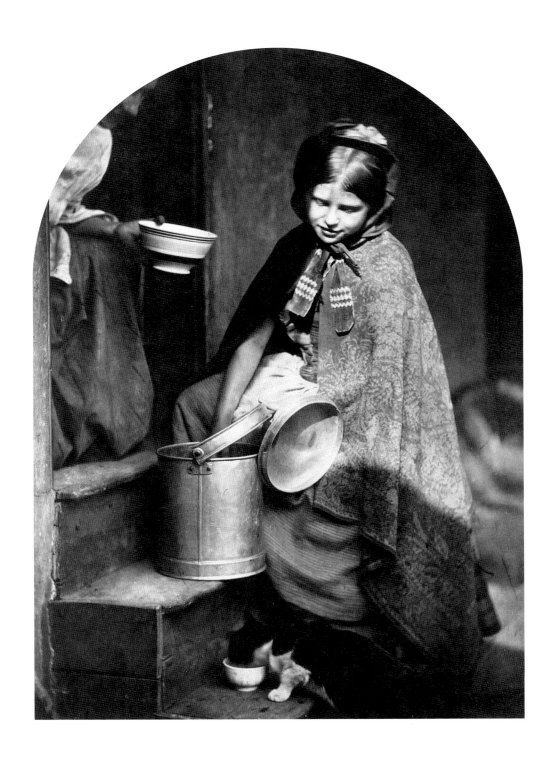

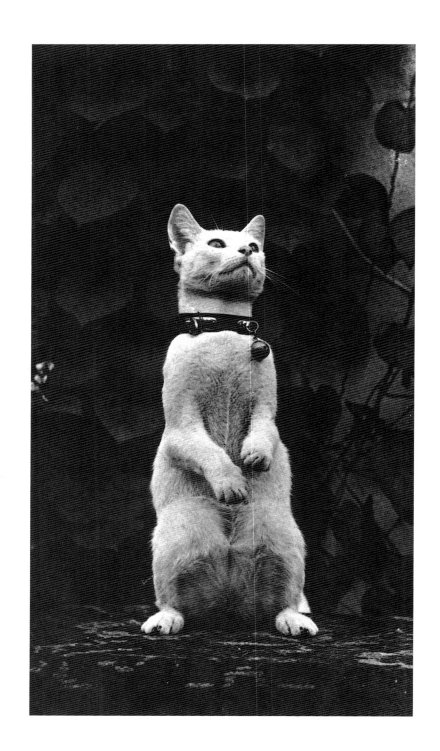

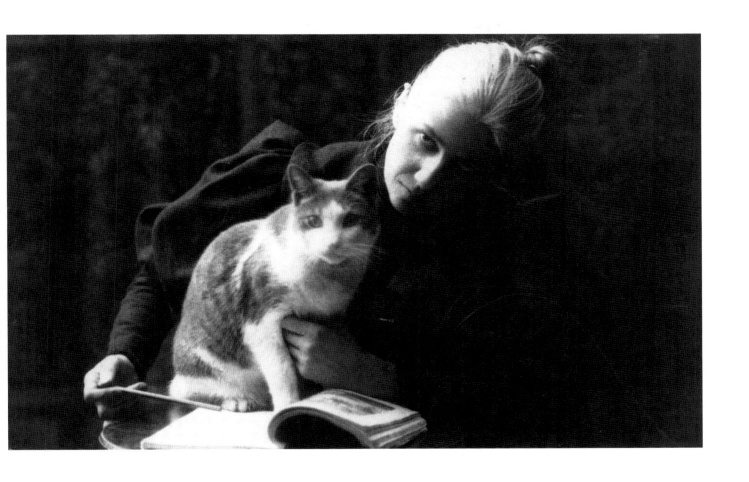

•11• THOMAS EAKINS, *The Cat in Eakins' Yard*, c. 1880–1890 •12• THOMAS EAKINS, *Amelia C. Van Buren*, c. 1891

•13• Photographer unknown, Untitled, c. 1885

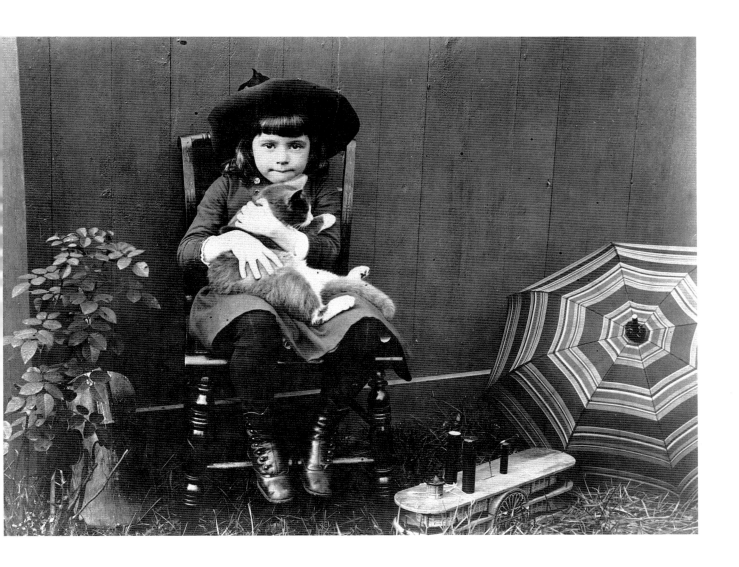

•14• Photographer unknown, *Tommy Morgan*, c. 1910

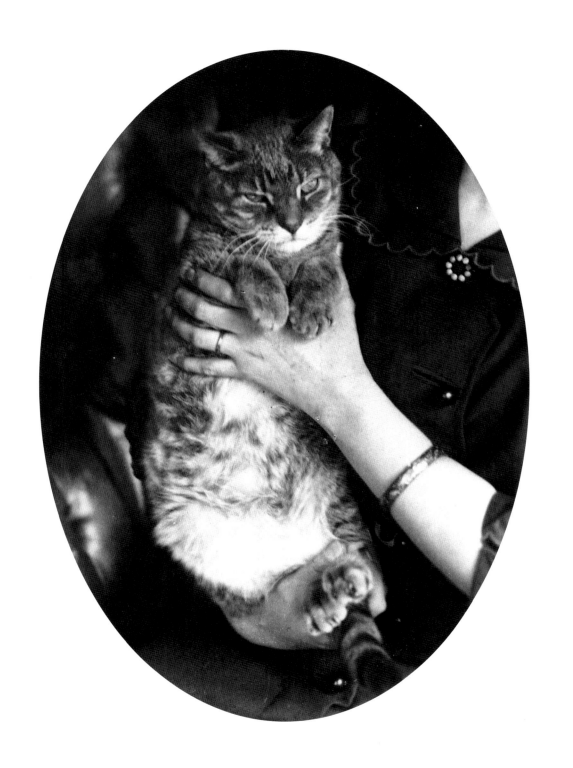

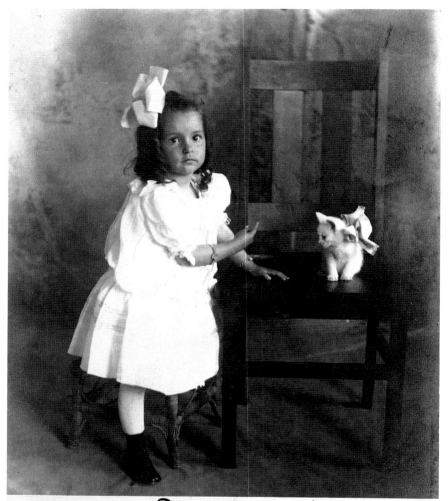

Poor Kittie geting a scolding

Dear Alice:;
 This is my dear little
Kittie isn't it cute?
 With love
 Little Mildred Perry.

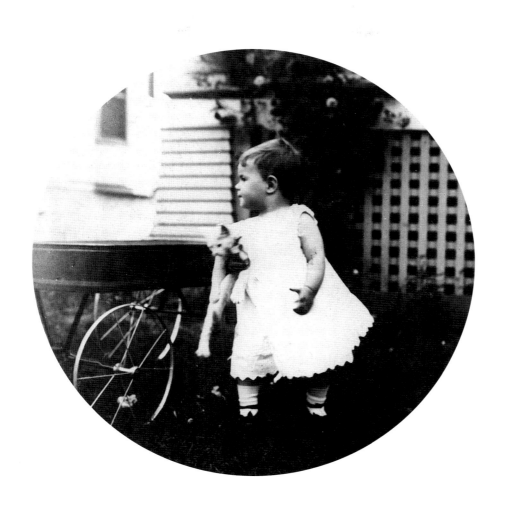

•15• Photographer unknown, *Poor Kittie Getting a Scolding*, 1906 •16• Photographer unknown, *Helen*, c. 1890

•17• Photographer unknown, *Cat Pushing Cart*, n.d.

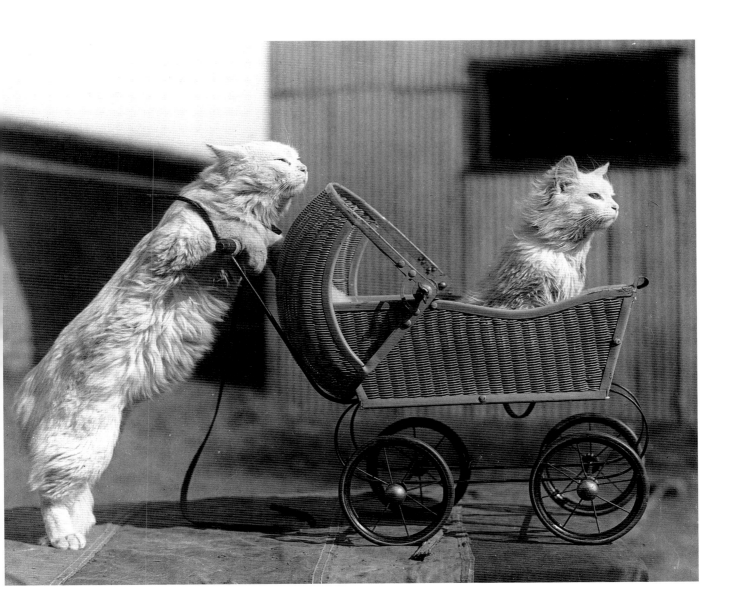

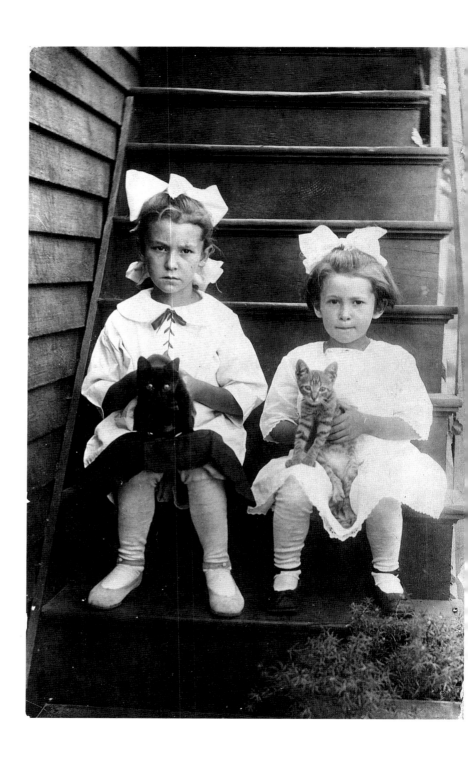

•18• Photographer unknown,
Untitled, c. 1910

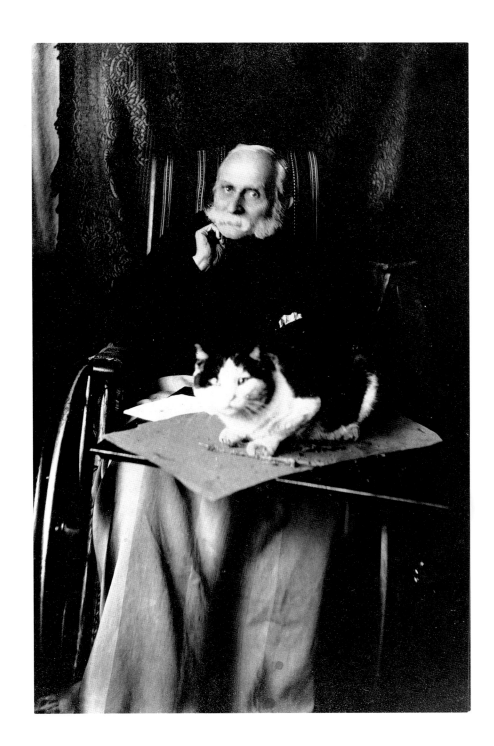

•19• Photographer unknown,
Untitled, 1909

•20• HARRY WHITTIER FREES,
A Sample Lot, 1905

•21• HARRY WHITTIER FREES,
The Pride of the School, 1905

DUNCE

THE PRIDE OF THE SCHOOL.

B 1197

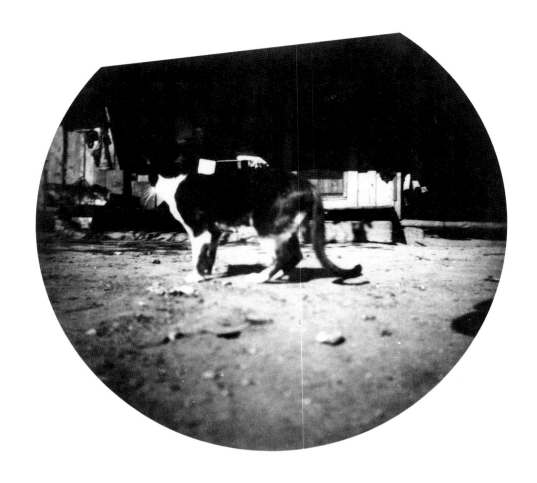

•22• Photographer unknown, Untitled, c. 1890

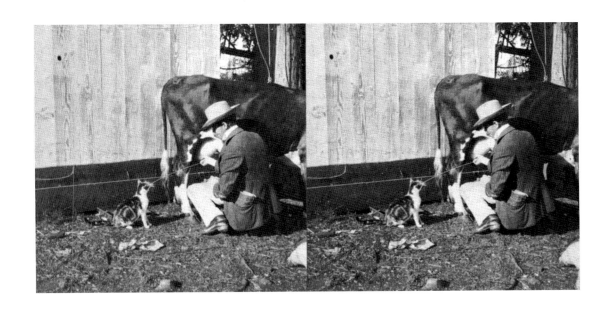

•23• JOHN H. BILLINGHURST, *Tabby at Breakfast*, 1905

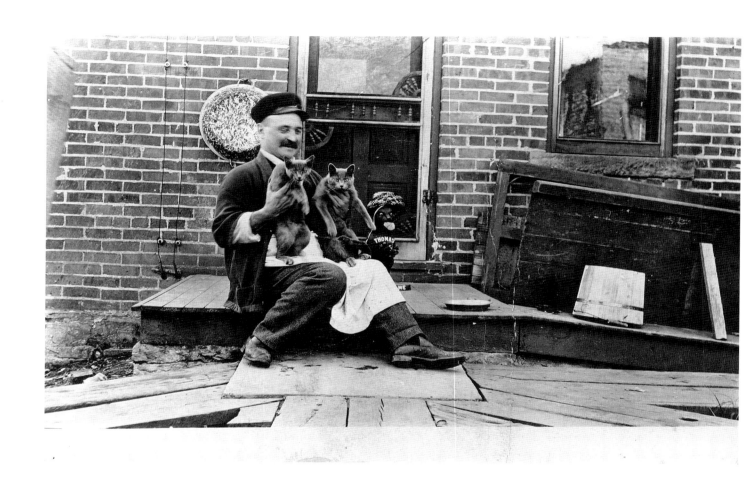

•24• Photographer unknown, Untitled, c. 1910 •25• Photographer unknown, Untitled, c. 1910

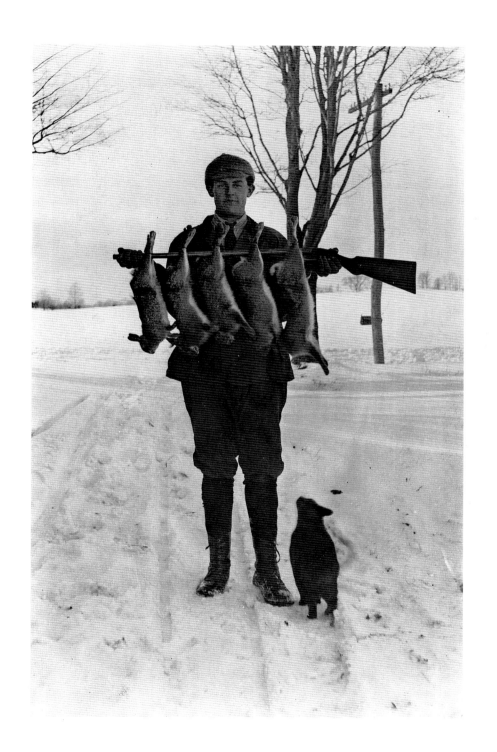

•26• Photographer unknown, *Violin Child*, c. 1930

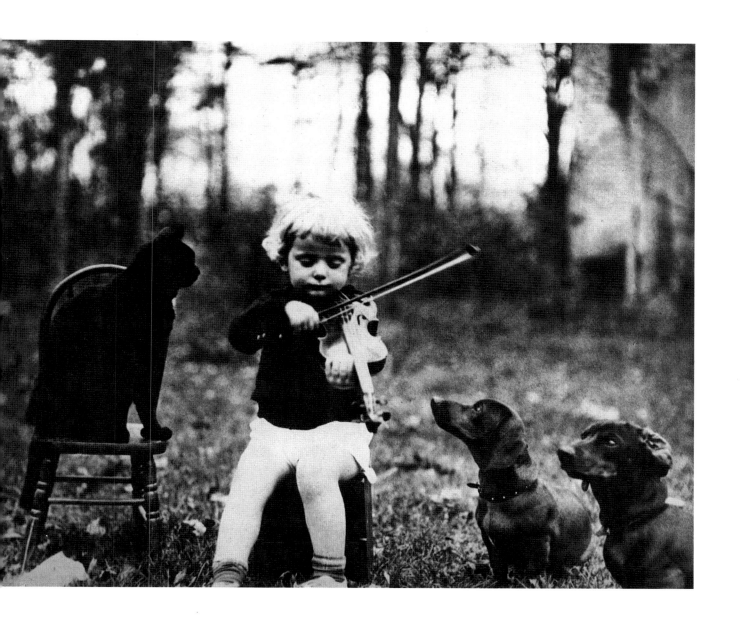

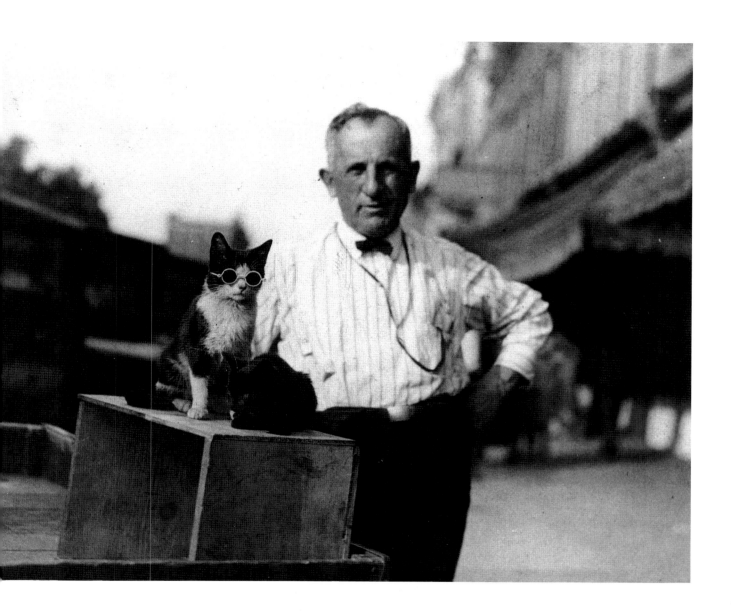

•28 • DARIUS REYNOLD KINSEY, *Logging Camp Cooks and Helpers,*
Bloedel-Donovan Logging Camp, Alger, Washington, September 12, 1918

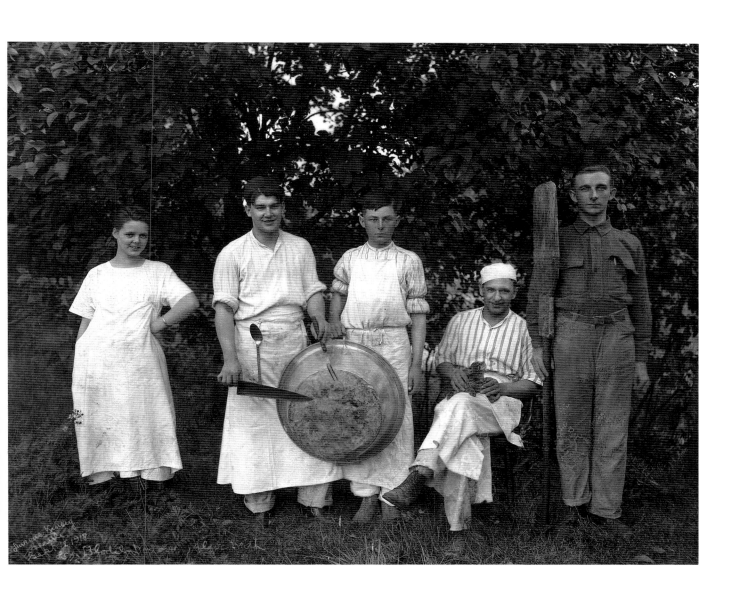

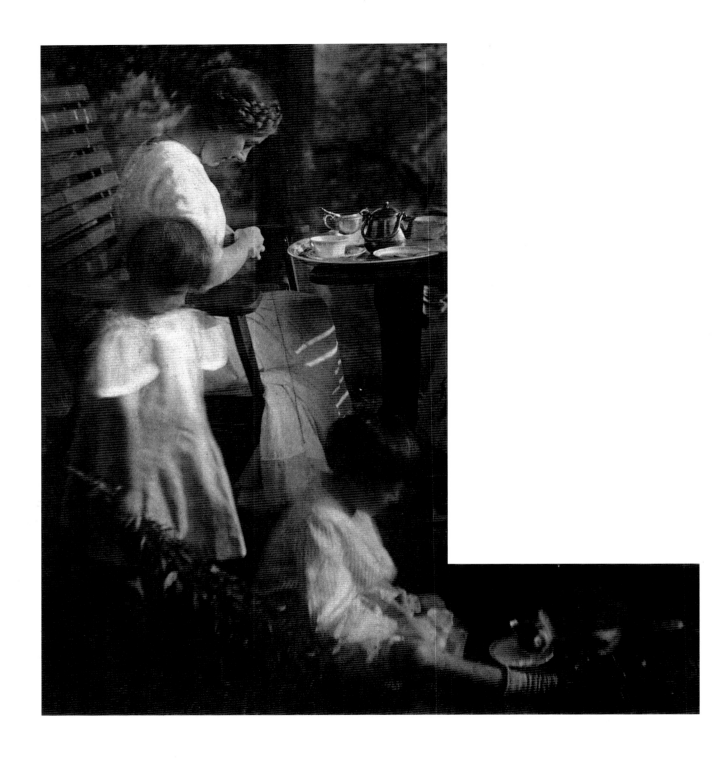

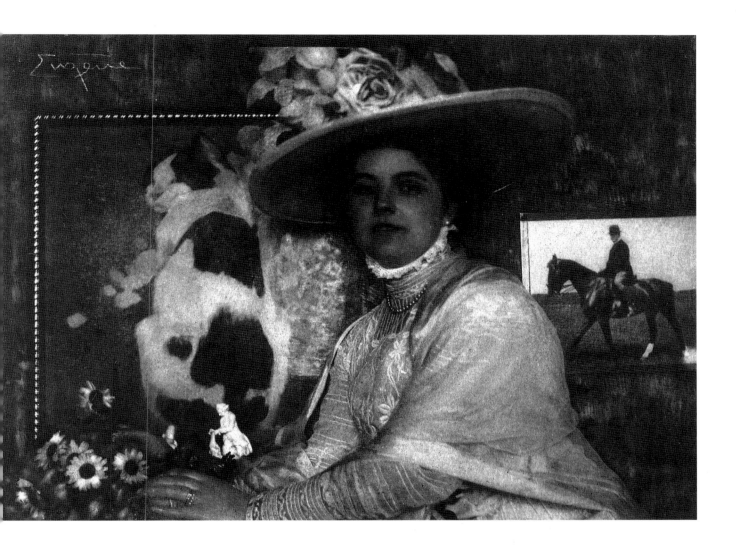

•29• GERTRUDE KÄSEBIER, *The Artist's Daughter,*
Hermine, and Her Children at Tea, 1911

•30• FRANK EUGENE,
Frau Ludwig von Holwein, 1910 (or earlier)

•31• HELEN M. BECHT, Untitled, c. 1930

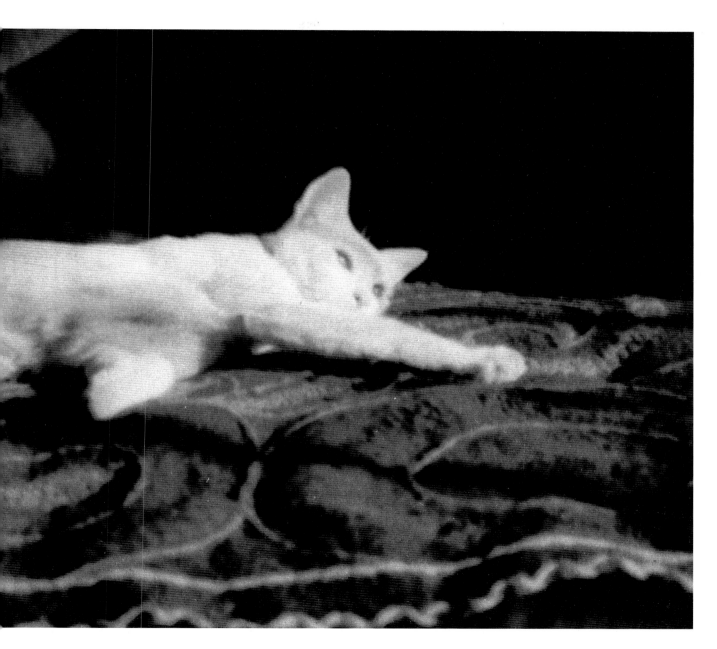

•32• JAMES VAN DER ZEE, *Smart Cat, New York City*, 1931

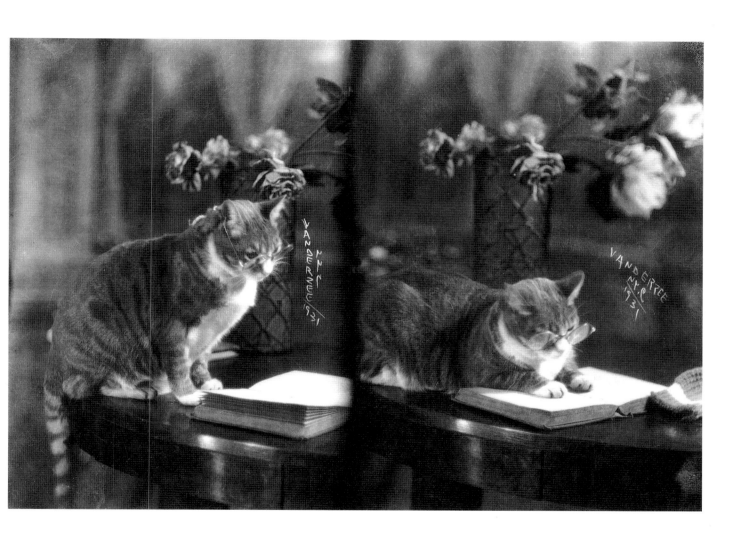

•33• RICHARD POLAK, *Merry Company*, 1913

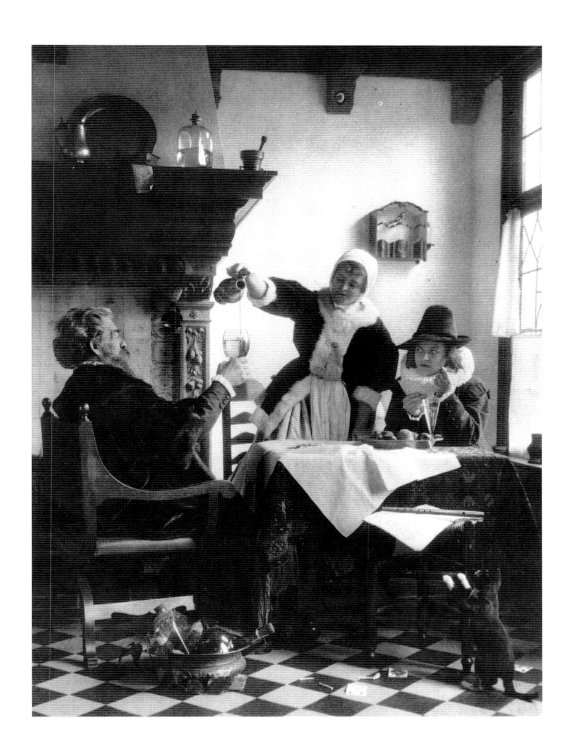

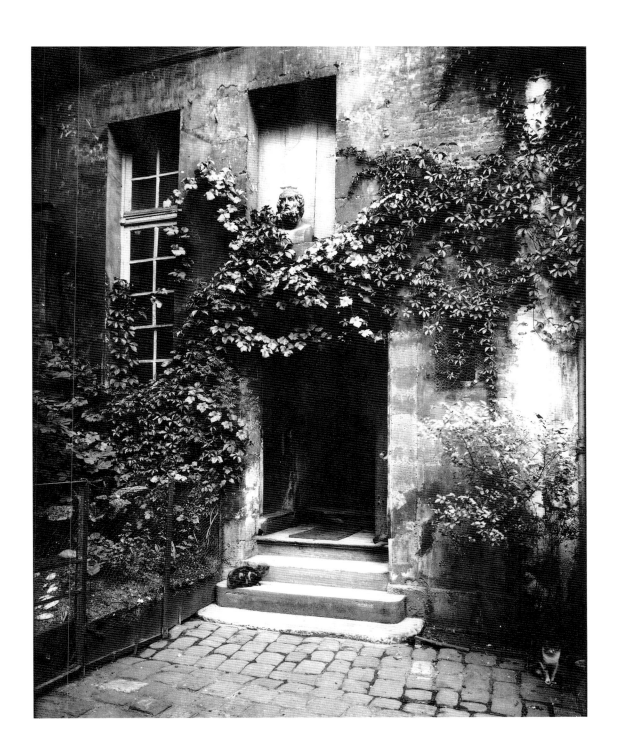

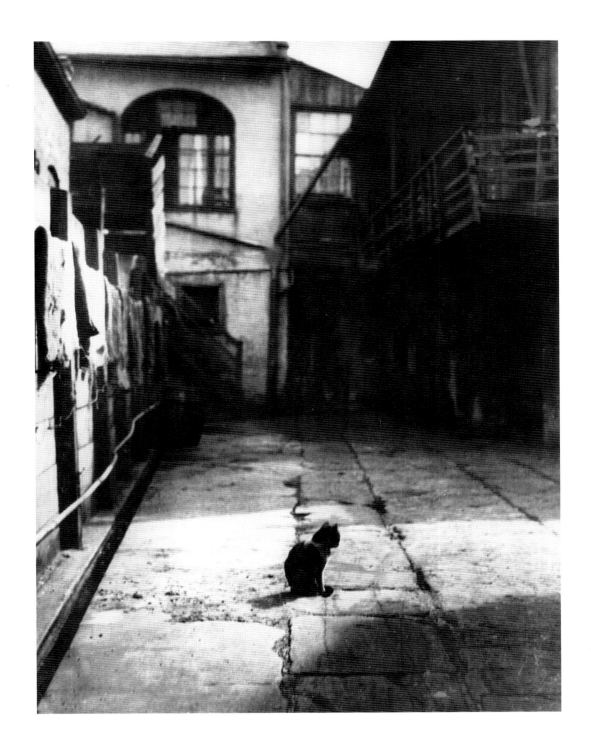

•36• ANDRÉ KERTÉSZ, *Rue Bourgeois*, 1931

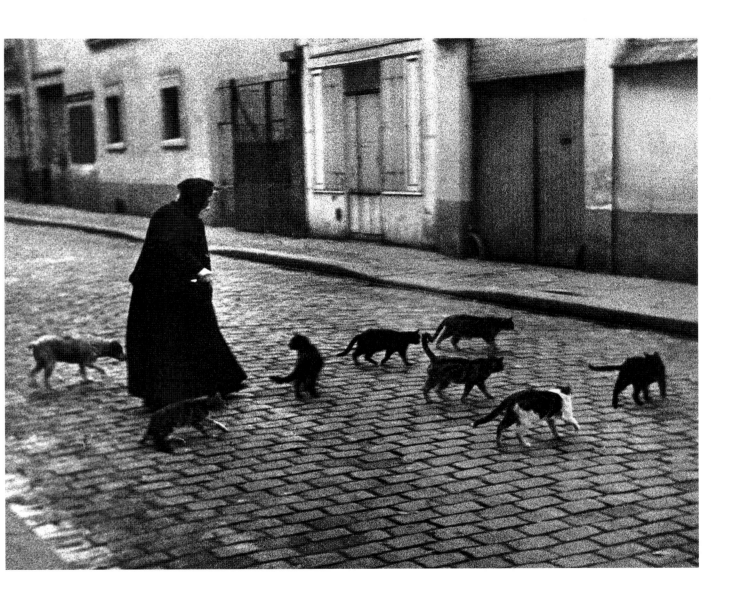

•37• ANDRÉ KERTÉSZ, *Paris*, 1928

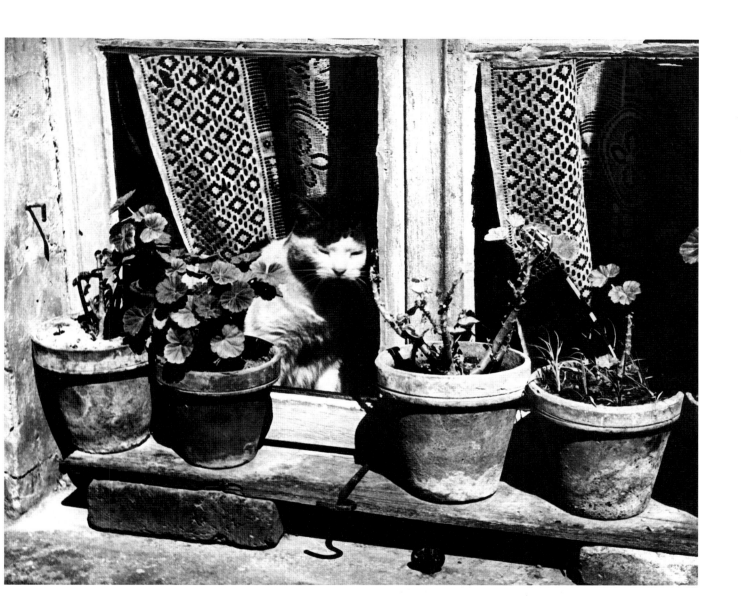

•38• HARRY WARNECKE, *Cat Crossing the Street in Traffic*, 1925

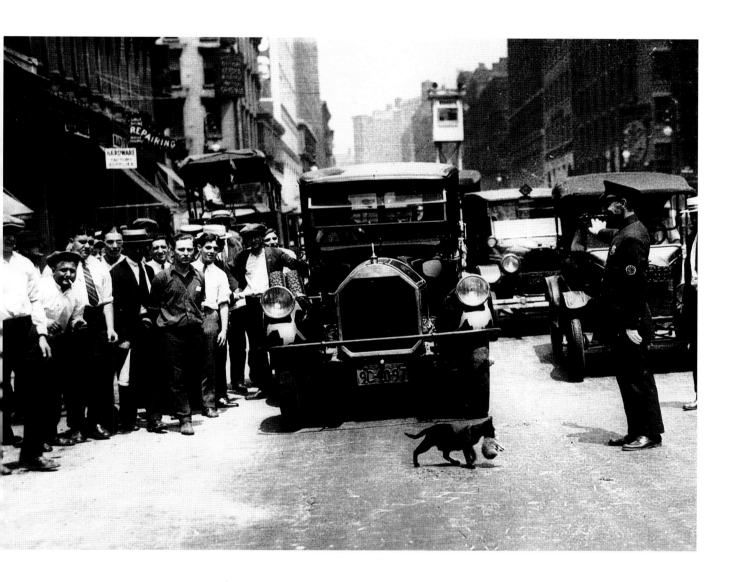

•39• Photographer unknown, *Animal Rescue League, Boston, Massachusetts*, c. 1940

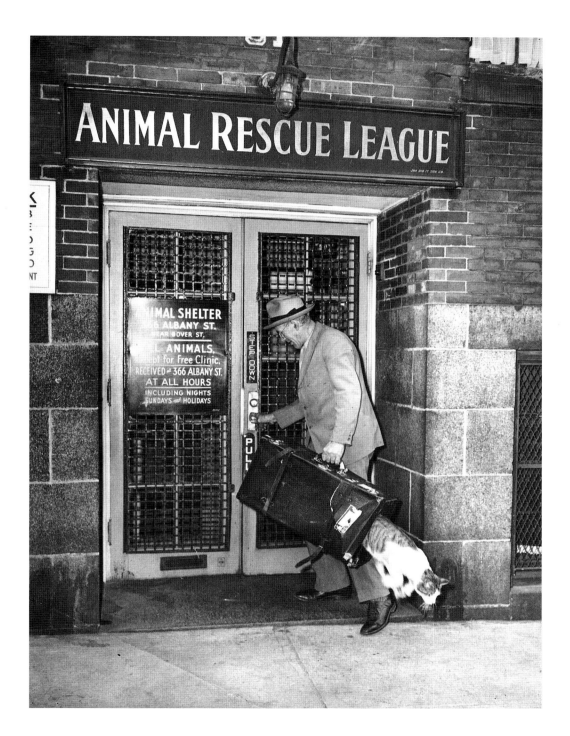

•40• CARL MYDANS, *Father and Son Wear Their Hats to Pose in Their Cincinnati Tenement*, 1936

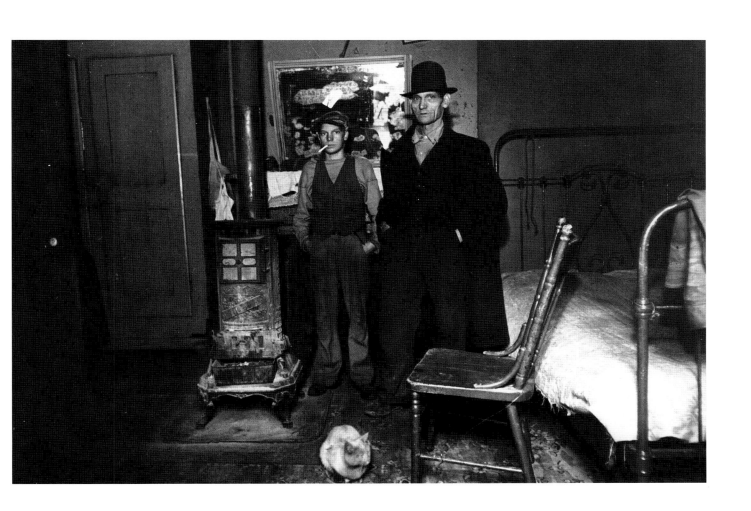

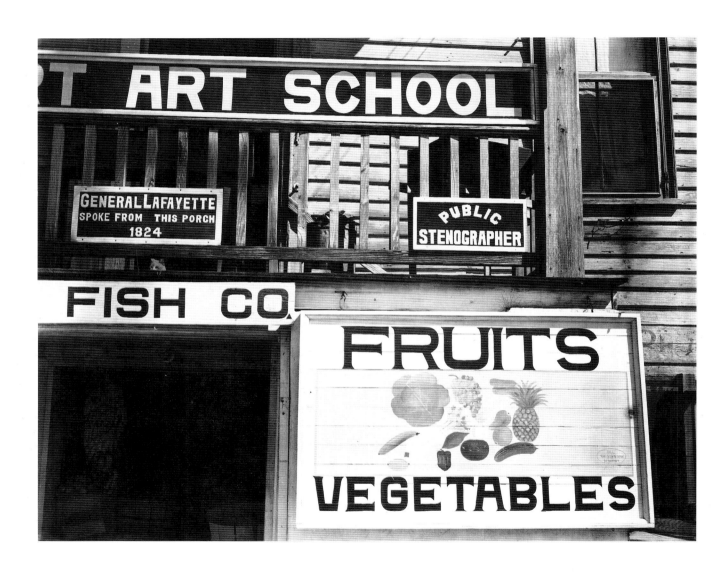

•41• WALKER EVANS, *Storefront and Signs, Beaufort, South Carolina*, March 1936

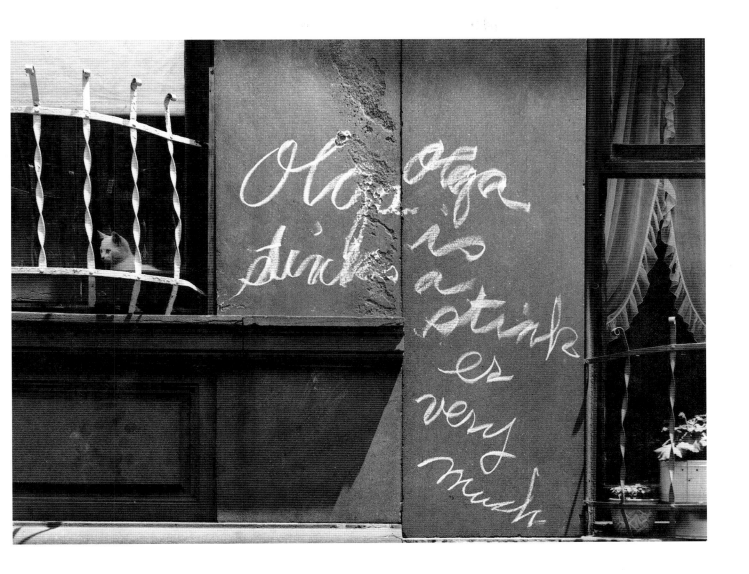

•42• HELEN LEVITT, *New York*, c. 1940

•43• HELEN LEVITT, *New York*, c. 1945

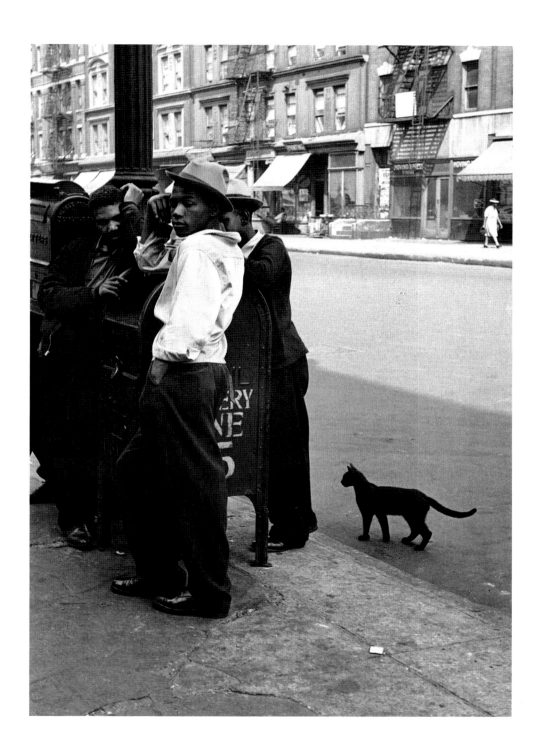

•44• WEEGEE [ARTHUR FELLIG], *Tenement Penthouse*, 1940

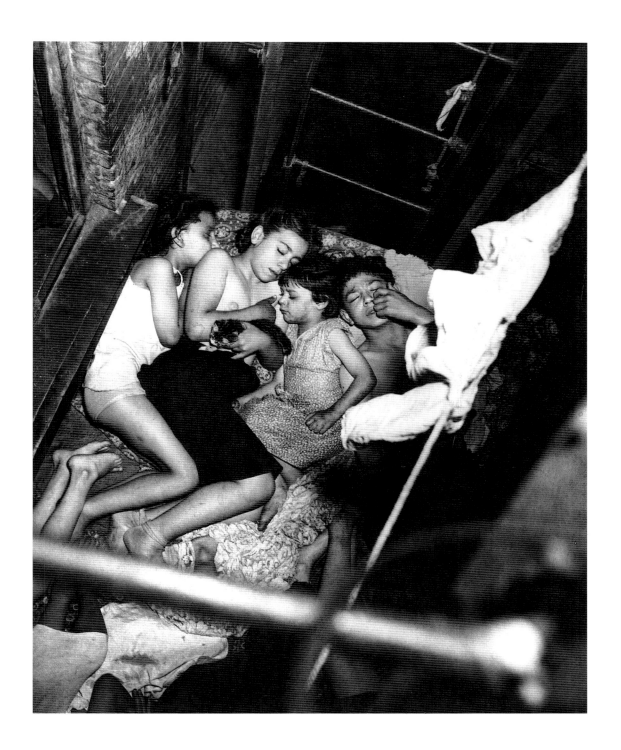

•45• MARION POST WOLCOTT, *A Fireplace in an Old Mud Hut Which Was Built and Is Still Lived In by a French-mulatto Family, near the John Henry Plantation, Melrose, Louisiana*, 1940

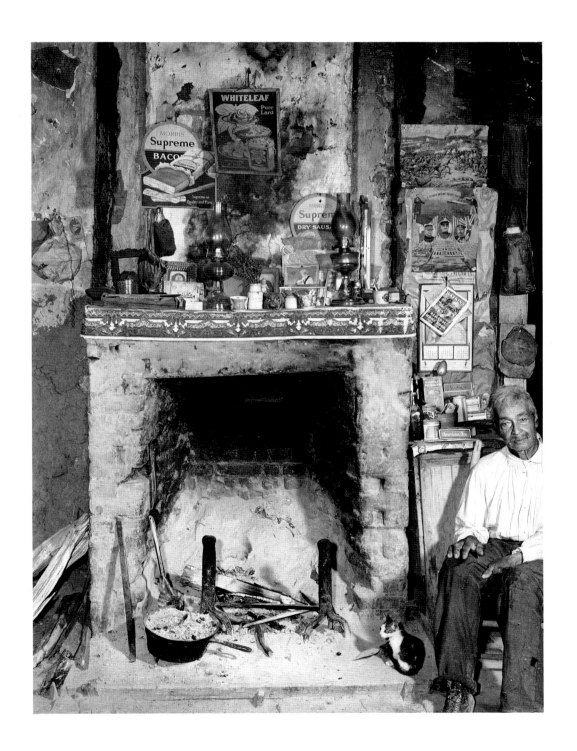

•46• WEEGEE [ARTHUR FELLIG], *Lady and Cat*, c. 1940

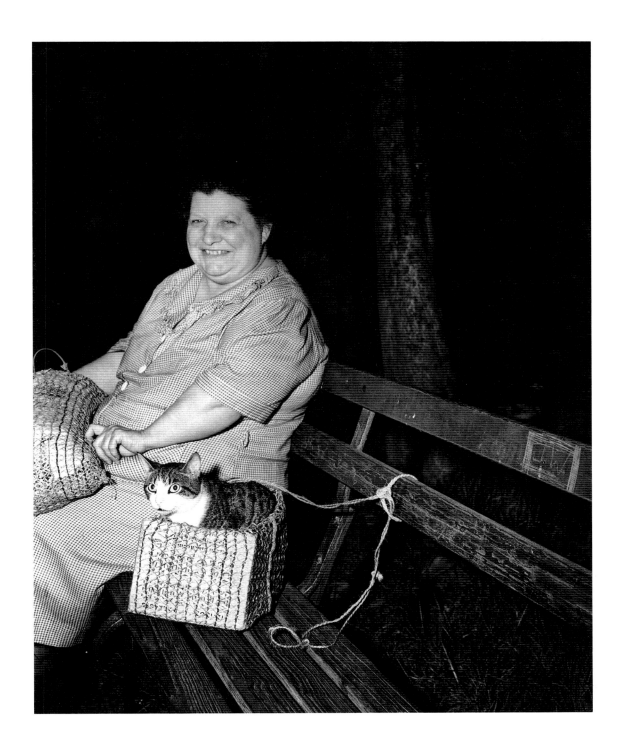

•47• JEAN-PHILIPPE CHARBONNIER, *The Cat, Lenoir-Jousserand Old Folks' Home, Saint Mandé*, 1959

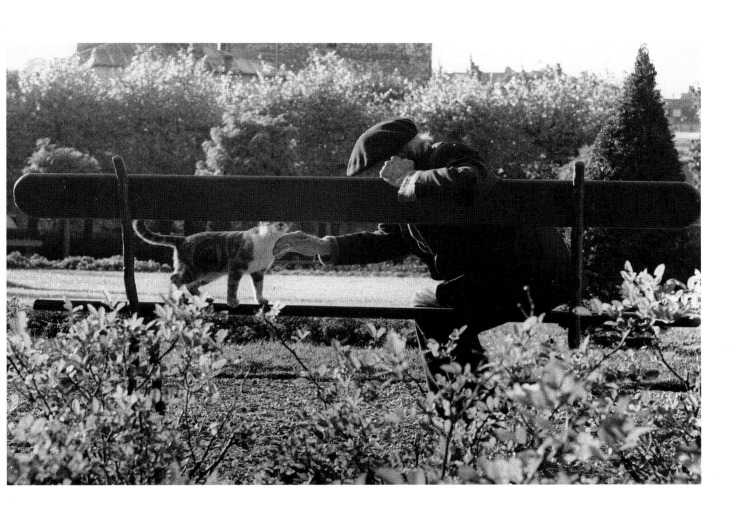

•48• RUTH ORKIN, *Old Women Feeding Cats, Rome*, 1951

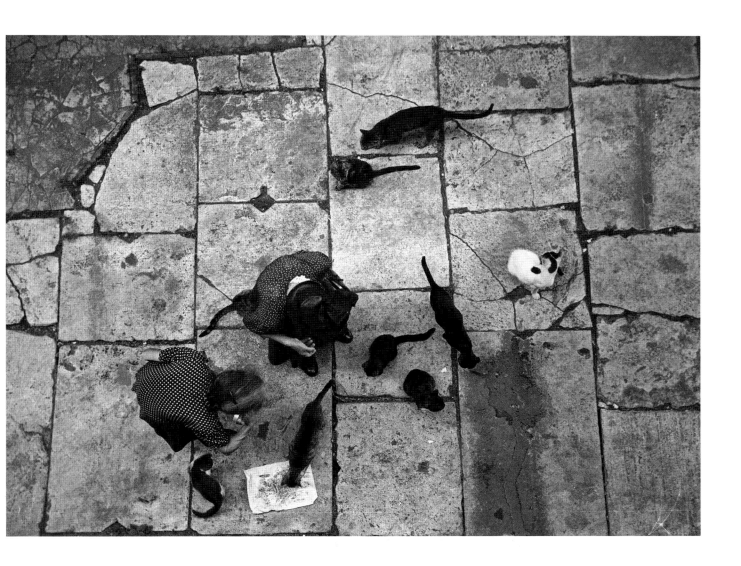

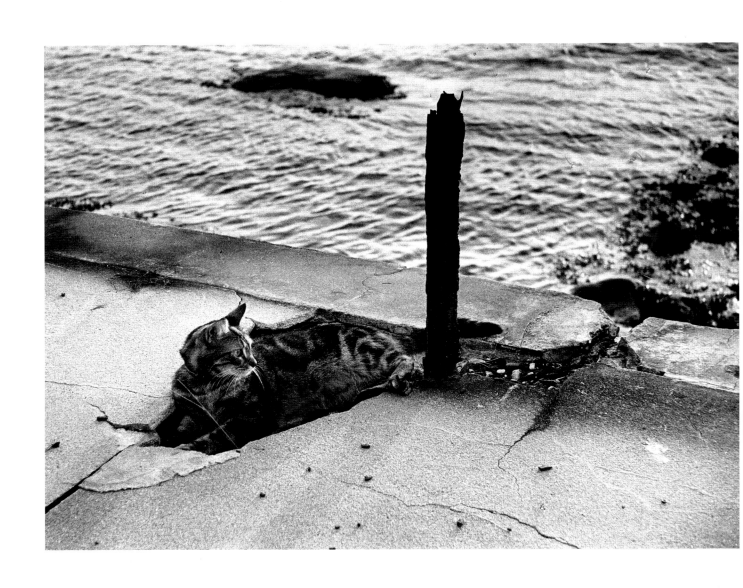

•49• DAN WEINER, *Beta Weiner, Shelter Island*, 1953

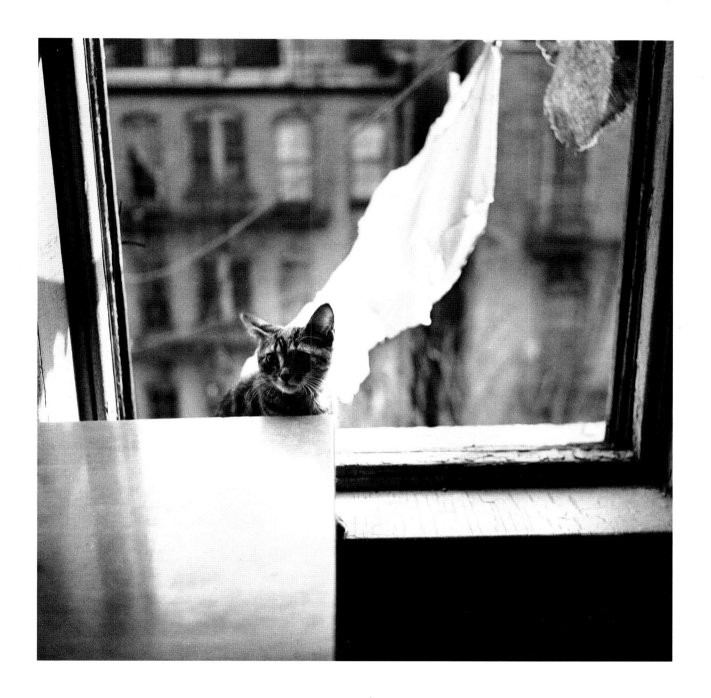

• 50 • SANDRA WEINER, *83rd Street and East End Avenue, New York City*, 1951

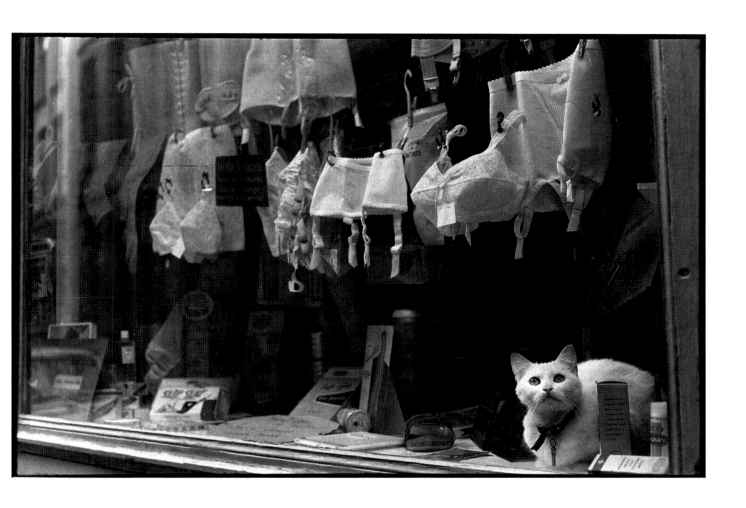

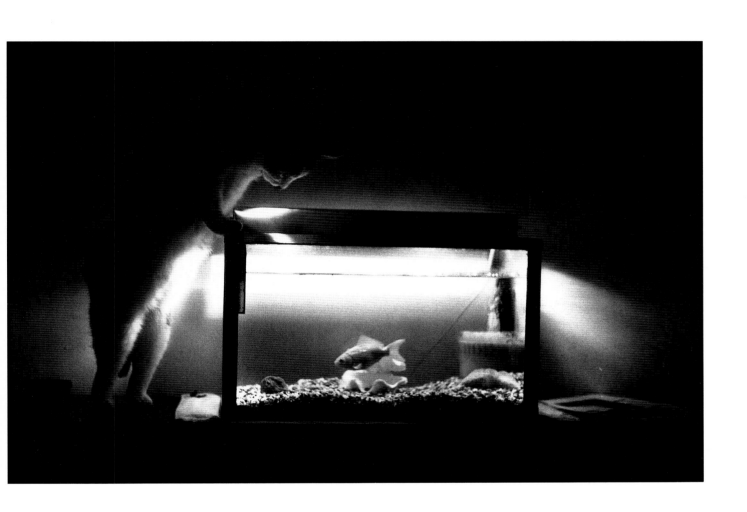

•53• DONALD McCULLIN, *Snowy, the Mouse Man, Oakington, Cambridgeshire*, n.d.

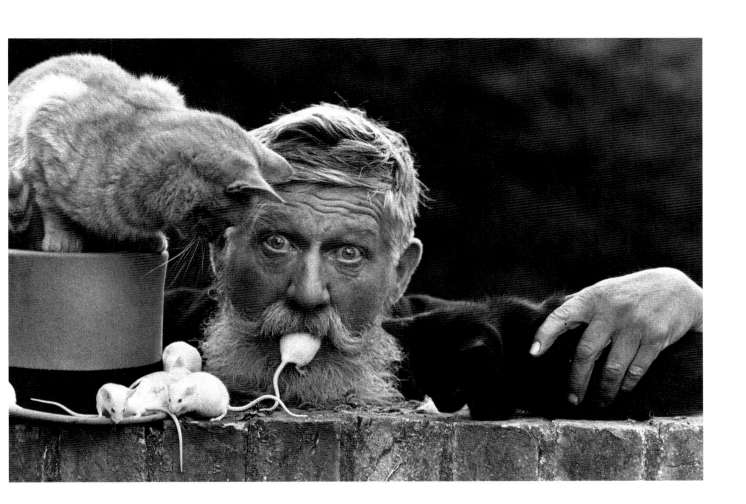

•54• ELLIOTT ERWITT, Untitled, n.d.

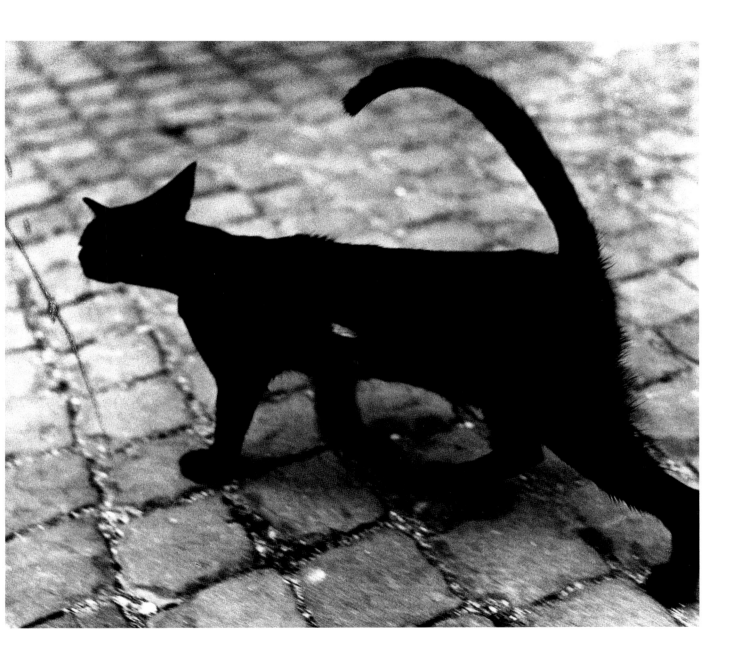

•55• LÁSZLÓ MOHOLY-NAGY, Untitled *(Negative Cat)*, c. 1926

•56• OSCAR NERLINGER, *The Cat*, 1930

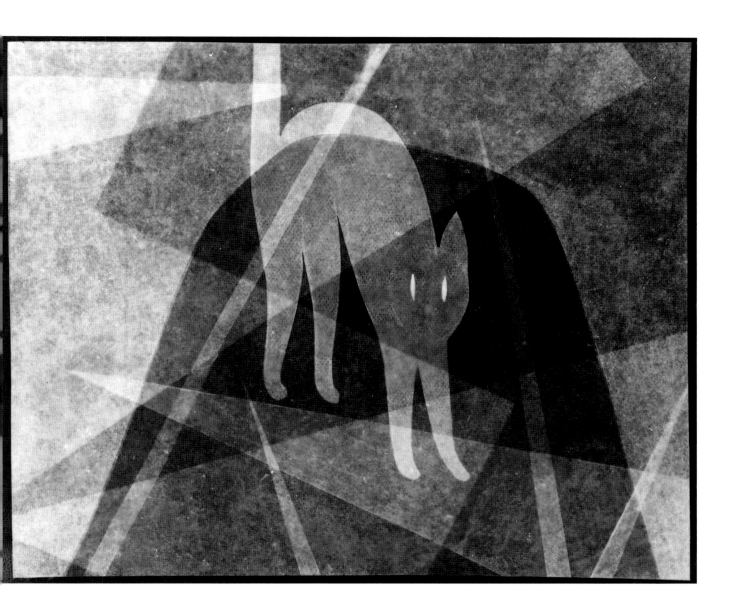

•57• AUGUST SANDER, *Corner of the Finishing Room at Cologne*
with Portraits of Franz Wilhelm Seiwert and Heinrich Hoerle, April 1943

•58• EDWARD WESTON, *Cats on Woodbox*, 1944 •59• EDWARD WESTON, *Cats on Steps*, 1944

•60• IMOGEN CUNNINGHAM, *Edward Weston, Photographer, with His Cats*, 1945

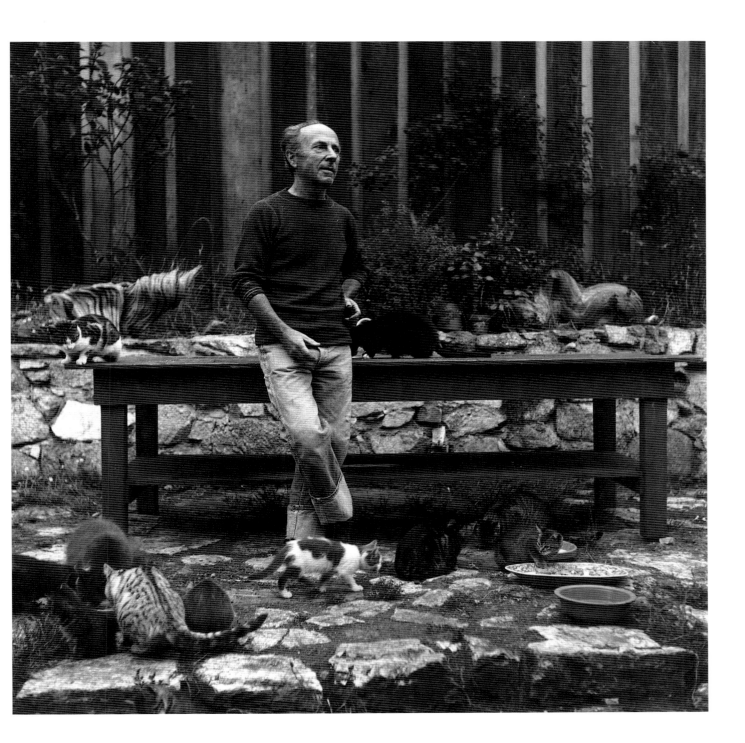

•61• LESLIE GILL, *Gentilini, Painter, and Daughter, Rome, Italy*, 1947

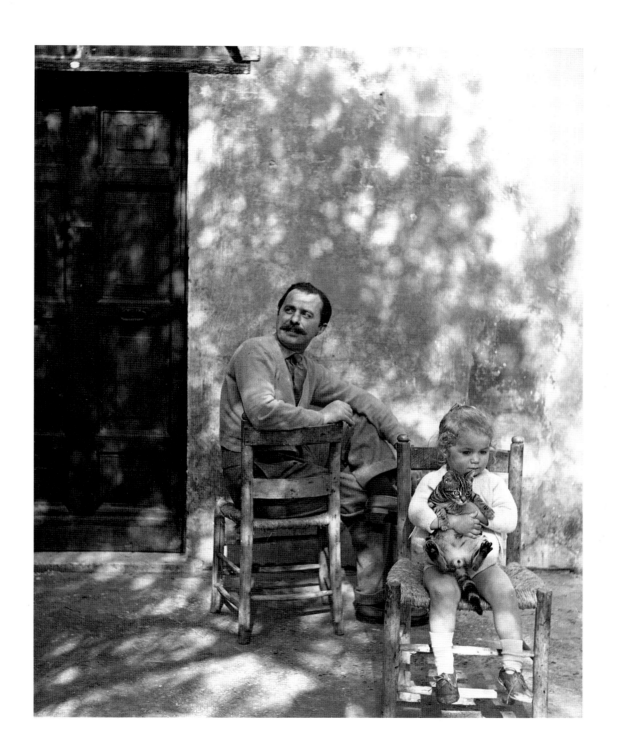

•62• BARBARA MORGAN, *Tossed Cats (Strobe)*, 1942

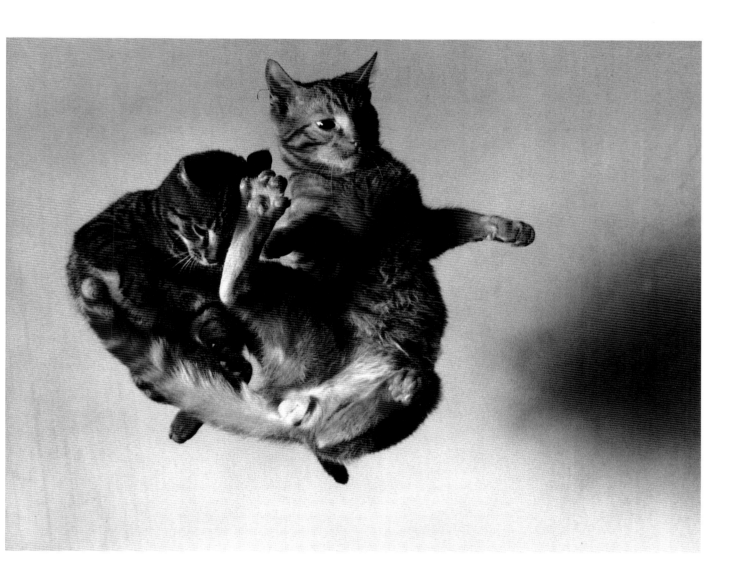

• 63 • K. J. GERMESHAUSEN, *"Plaster" Turns Over and Makes a Four-Point Landing, New England Cat Club Show*, December 1948

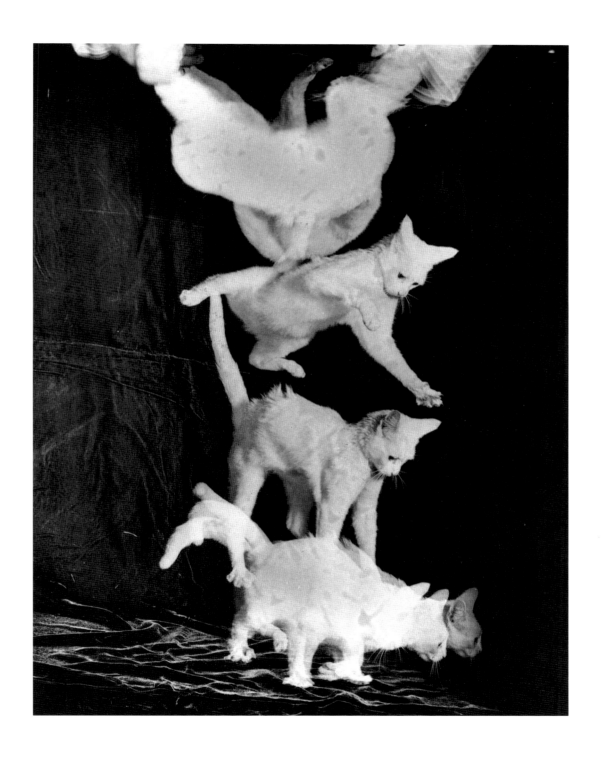

• 64 • PHILIPPE HALSMAN, *Dalí Atomicus*, 1948

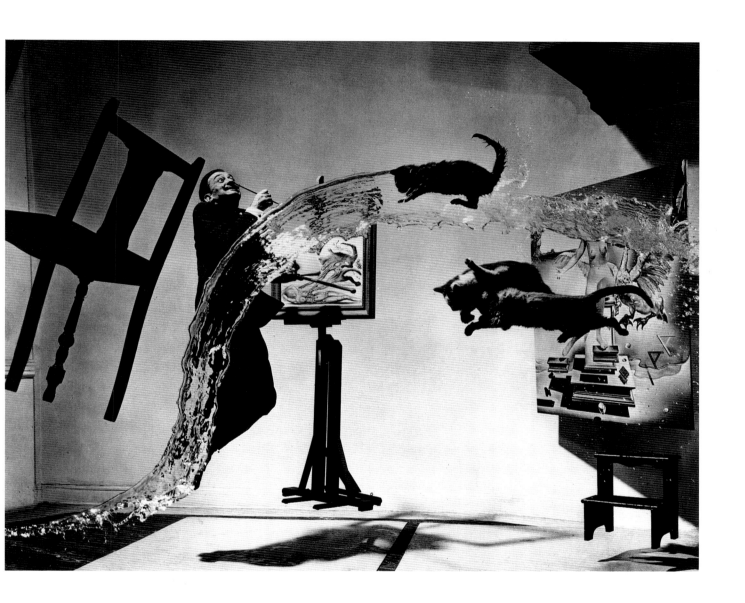

•65• MARTHA SWOPE, *George Balanchine and Mourka*, 1965

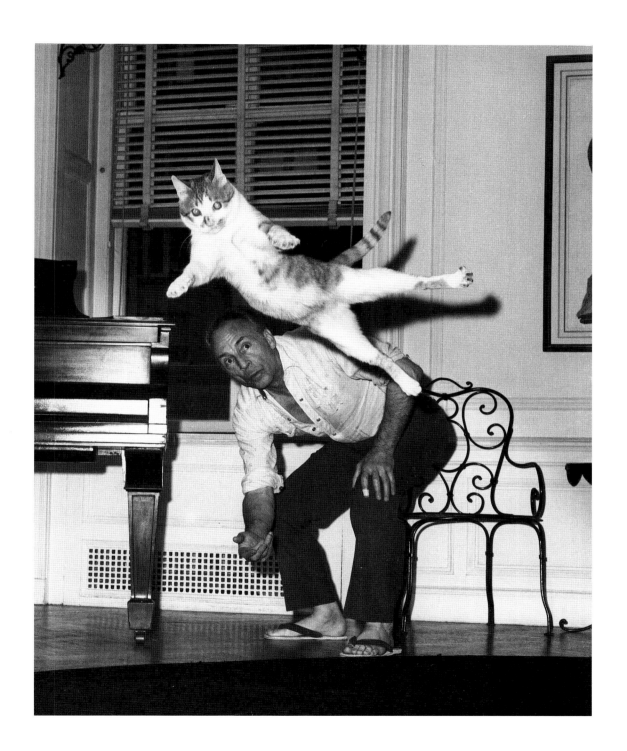

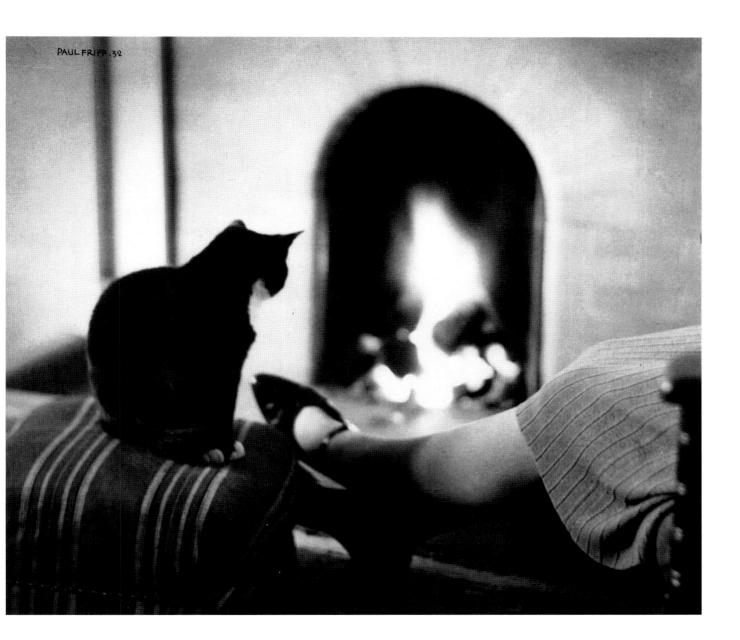

PAUL FRIPP.32

•67• ANDRÉ KERTÉSZ, *Studio Cat*, 1927

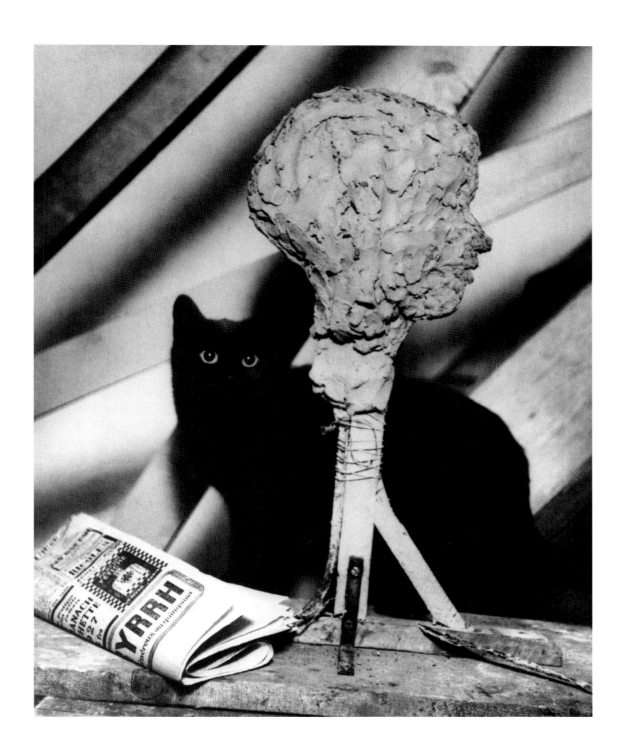

• 68 • EDWARD STEICHEN, *Noel Coward*, 1932

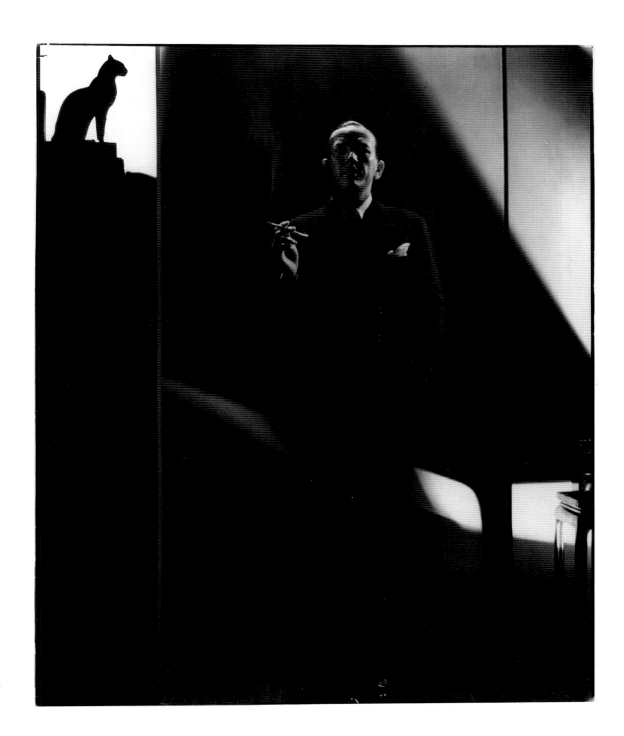

•69• WANDA WULZ, *My Cat and I*, 1932

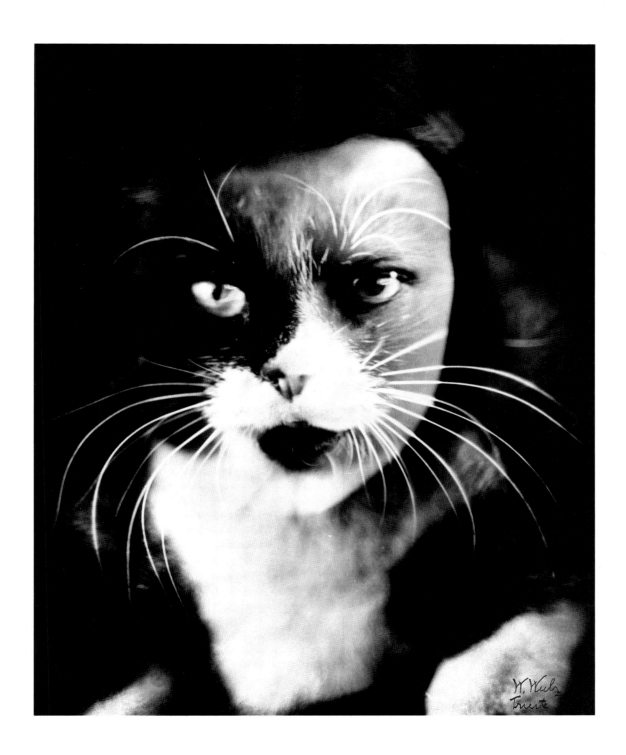

•70• MADAME D'ORA [DORA KALLMUS], *Tsugouharu Foujita*, c. 1935

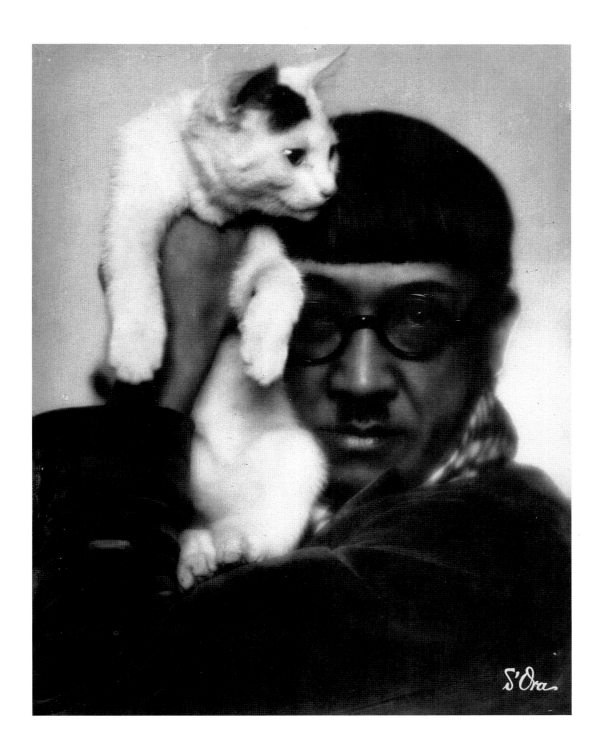

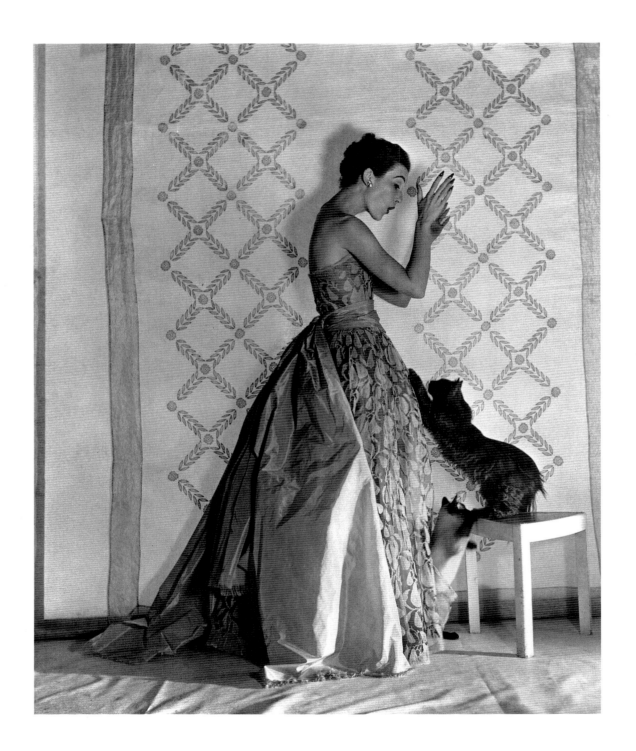

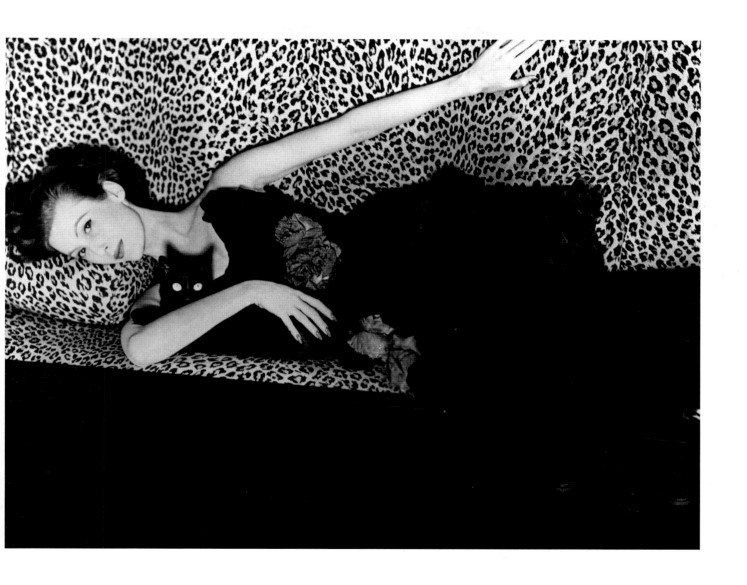

•71• LOUISE DAHL-WOLFE, *Mary Jane Russell in Gown Embroidered with Beads, Paris*, 1951

•72• LOUISE DAHL-WOLFE, *Mary Jane Russell on Leopard Sofa, Paris*, 1951

•73• RICHARD AVEDON, *Suzy Parker and China Machado with Robin Tattersall and Dr. Reginald Kernan,*
Evening Dresses by Balmain and Patou, La Pagode d'Or, Paris, January 1959

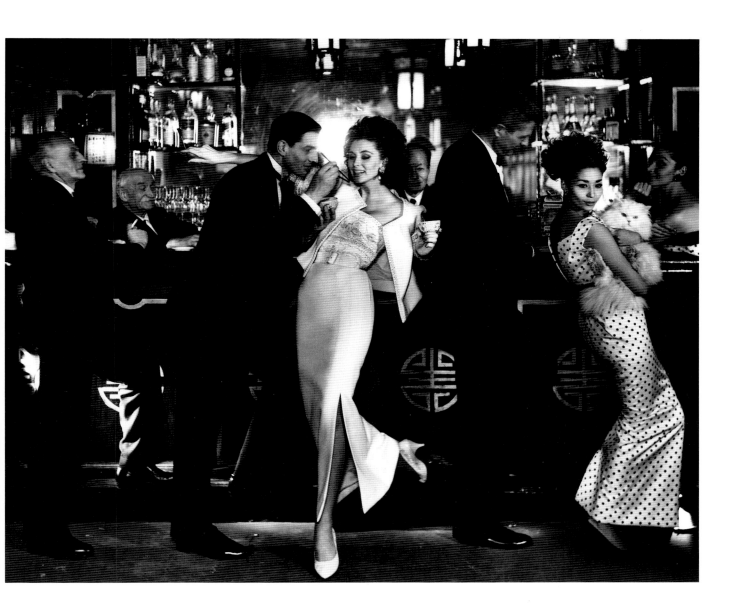

•75• ELLIOTT ERWITT, *Cat Show, New York City*, n.d.

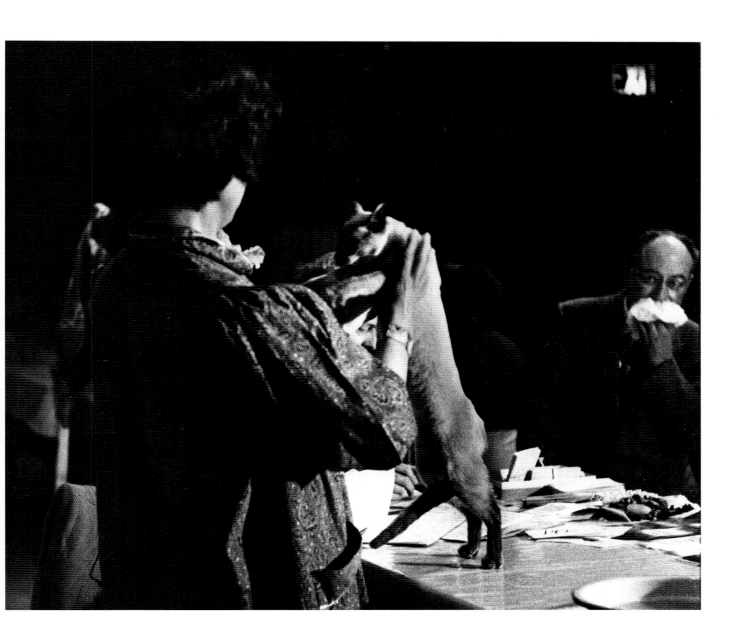

•76• JILL FREEDMAN, *Gladys and Shorty*, 1971

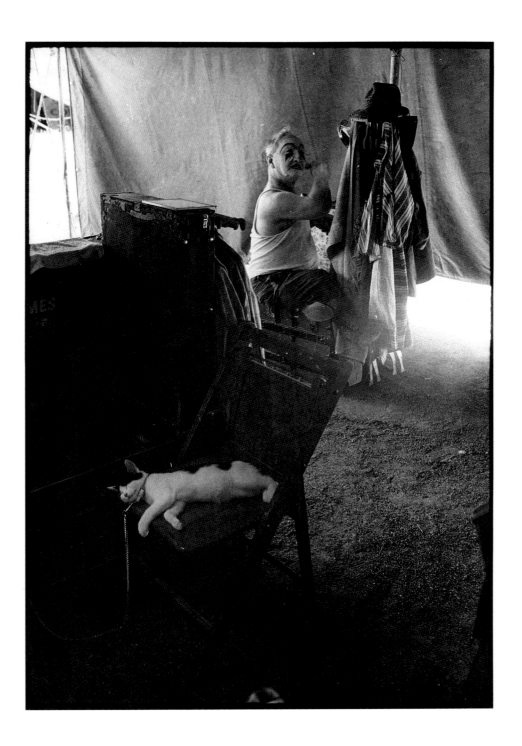

•77• JEAN-PHILIPPE CHARBONNIER,
Sunday in Spring, Paris, 1970

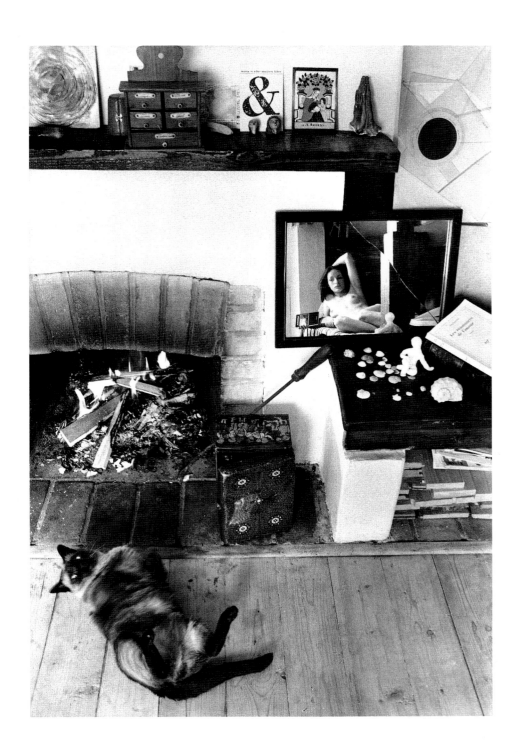

•78• MARC RIBOUD,
Nude in Prague, 1981

●79● SIR CECIL BEATON, *Antonia, Lady Aberconway's Cat at Bodnant*, May 24, 1960

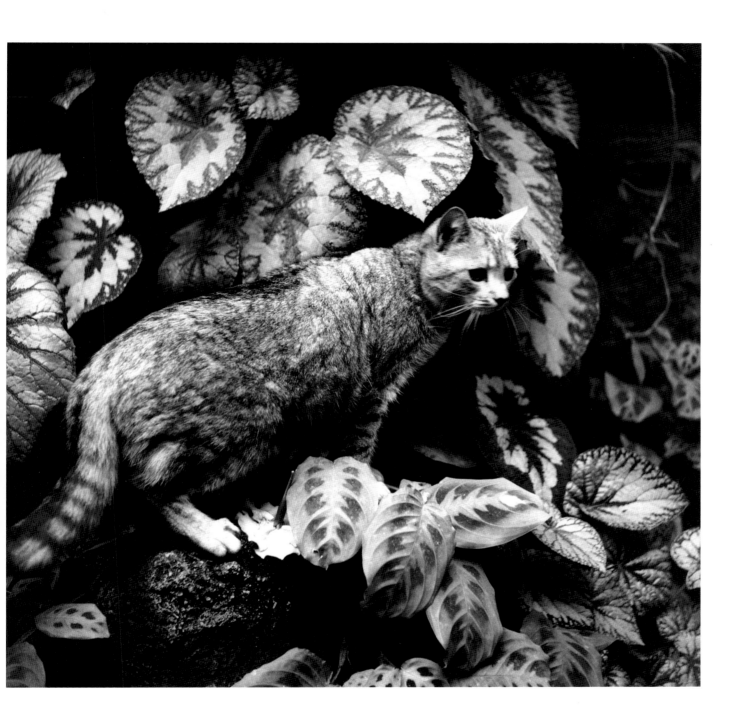

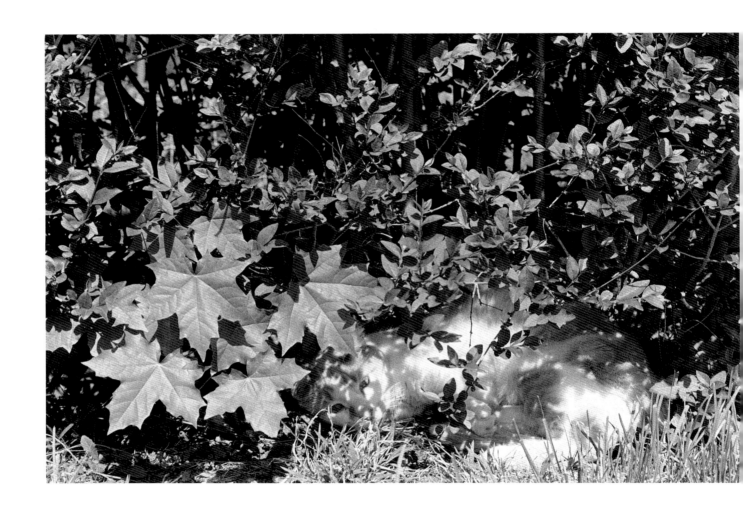

•80• ELAINE MAYES, *Leland under the Hedge, Florence, Massachusetts*, 1976

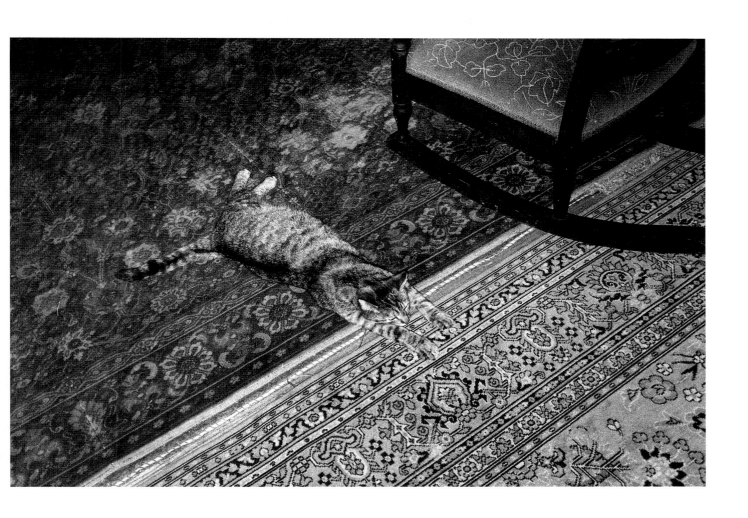

•81• ELAINE MAYES, *Tweede*, 1973

•82• ELAINE MAYES, *Red on the Table, Florence, Massachusetts*, 1973

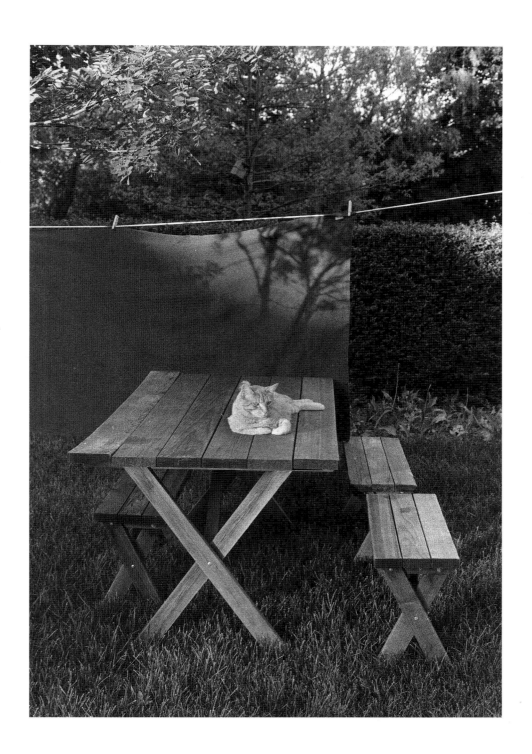

•83• EDOUARD BOUBAT, *Amish Farm, Pennsylvania, U.S.A.*, 1979

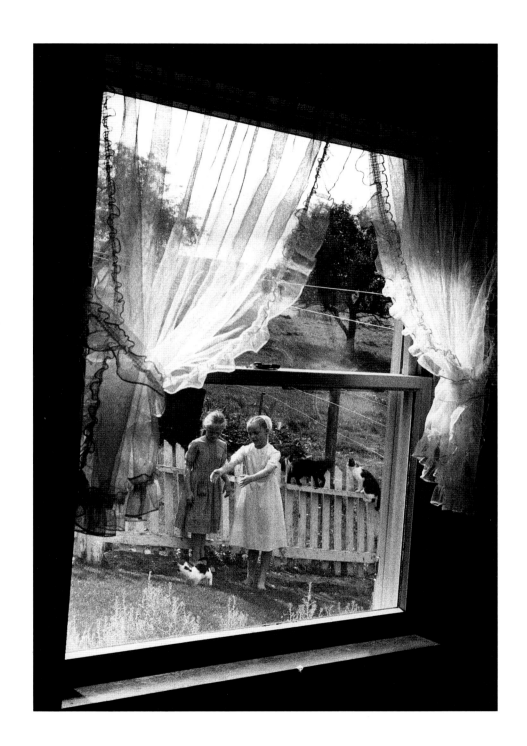

•84• ARTHUR FREED, Untitled, Israel, 1982

•85• ARTHUR FREED, Untitled, Israel, 1982

• 86 • JOHN KIMMICH, *Gardens of the Alhambra, Granada, Spain*, 1988

•87• LEE FRIEDLANDER, *Houston*, 1977

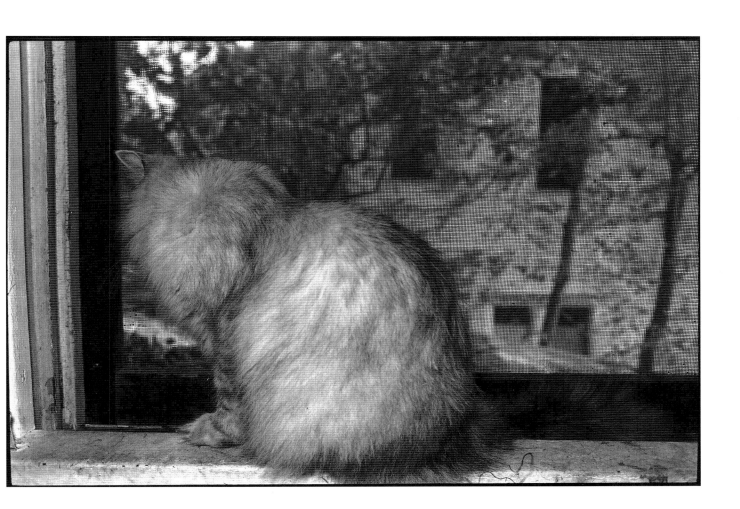

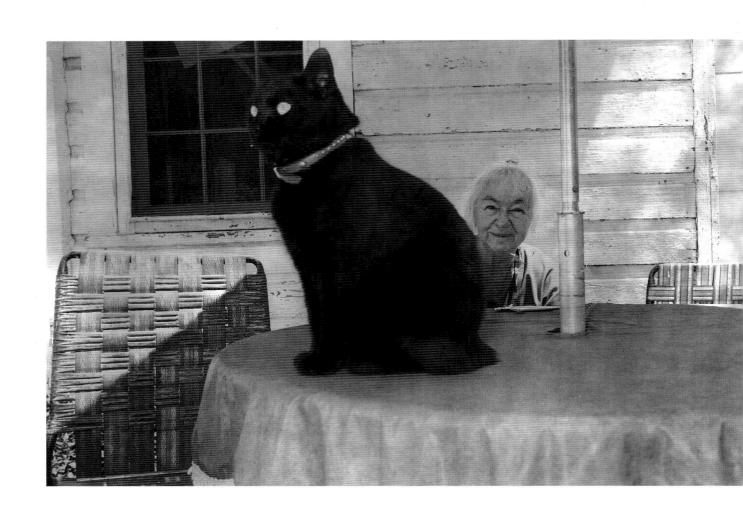

• 88 • LEE FRIEDLANDER, *Martha Ryther, New City, New York*, 1976

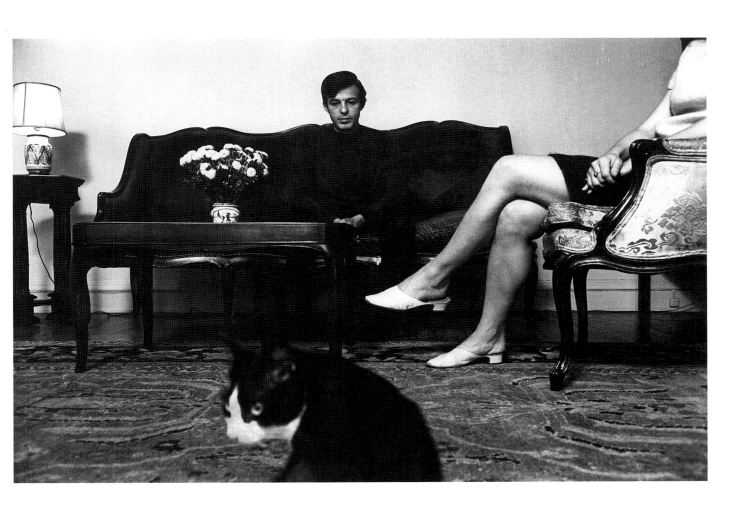

•89• LEE FRIEDLANDER, *Bob Blechman, New York City*, 1968

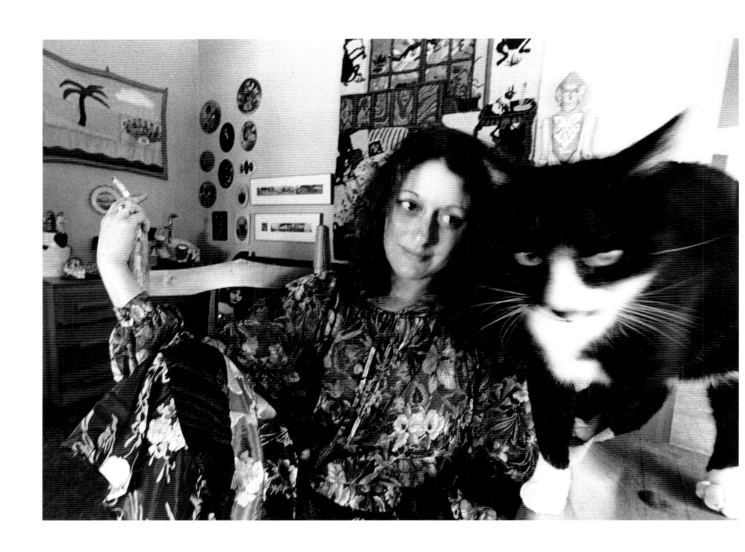

•90• ANNE NOGGLE, *Karen*, 1978 •91• ANNE NOGGLE, *Morris*, 1976

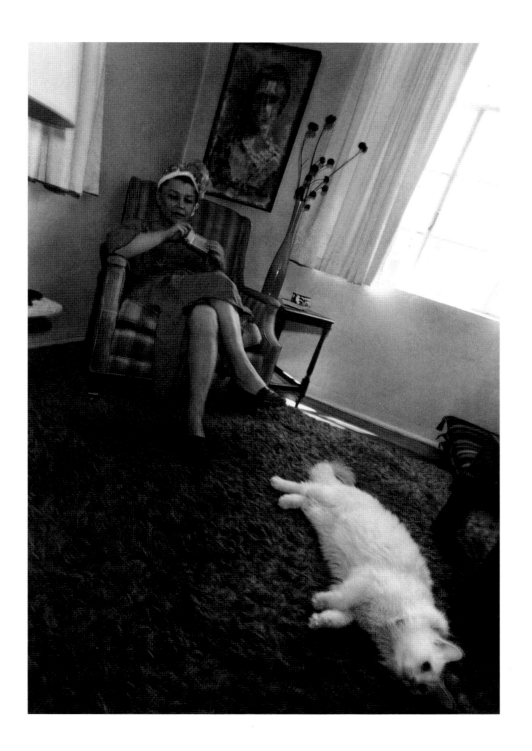

•92• NICHOLAS NIXON, *Kinnaird Street, Cambridge*, 1981

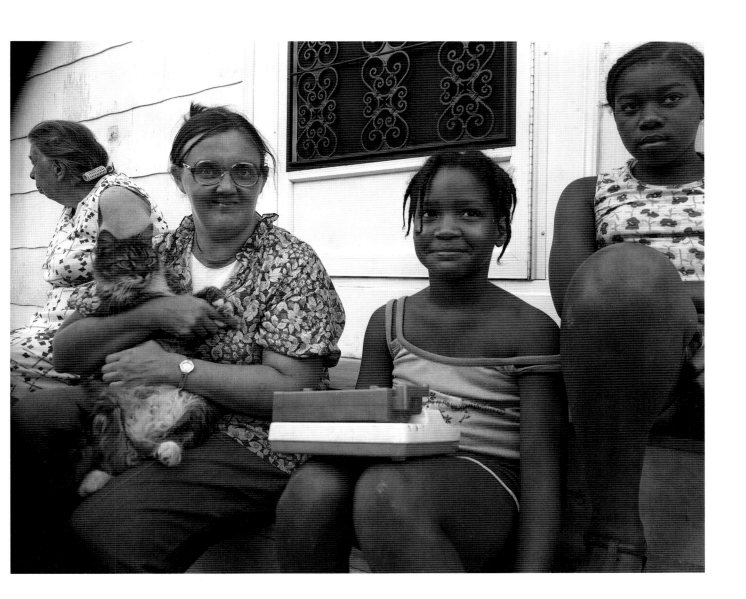

•93• SAGE SOHIER, *Brookline, Massachusetts*, 1986

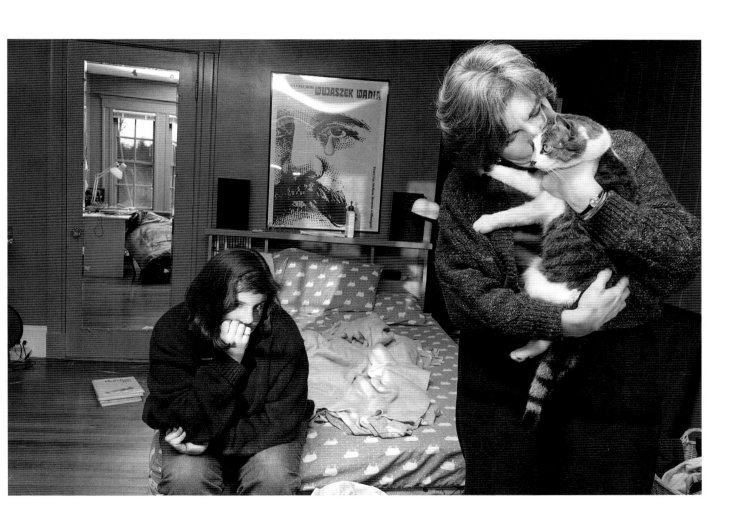

•94• DUANE MICHALS, *Homage to Cavafy*, 1978

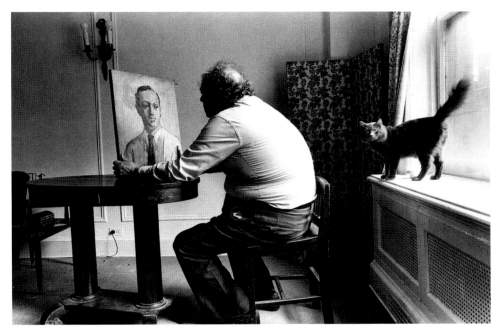

When he was a young man, it ~~never~~ seemed impossible that he would ever grow old. Now that he is old, he cannot remember ever having been young.

•95• TONY MENDOZA, Untitled (from the *Ernie* series), 1983

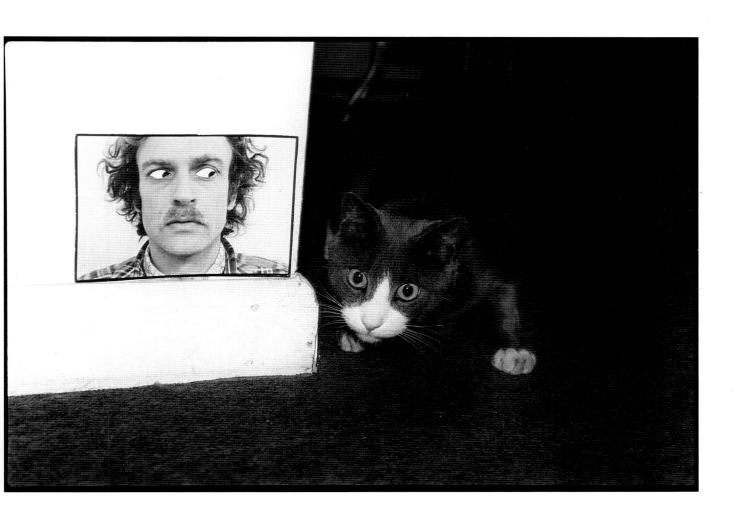

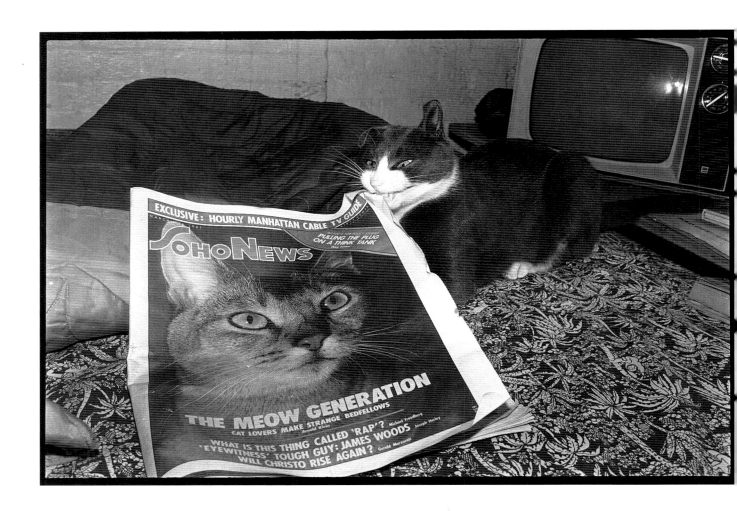

•96• TONY MENDOZA, Untitled (from the *Ernie* series), 1983

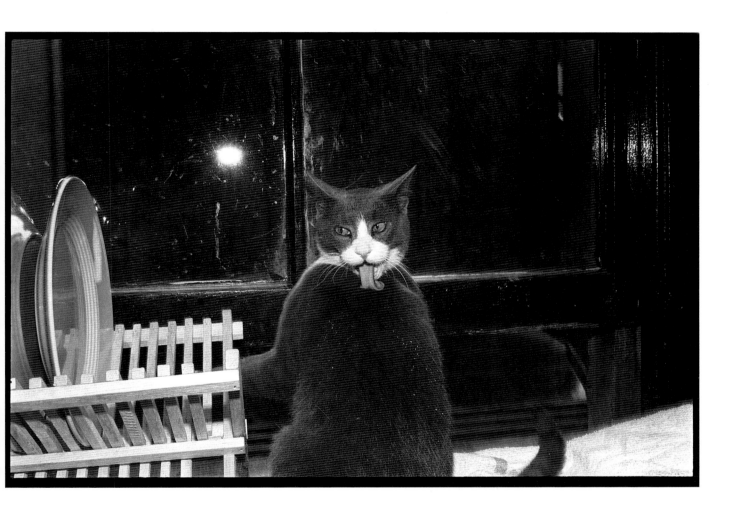

•97• TONY MENDOZA, Untitled (from the *Ernie* series), 1983

•98• DAVID AVISON, *Puck, Wilmette, Illinois,* 1983

•99• JAN GROOVER, Untitled, 1982

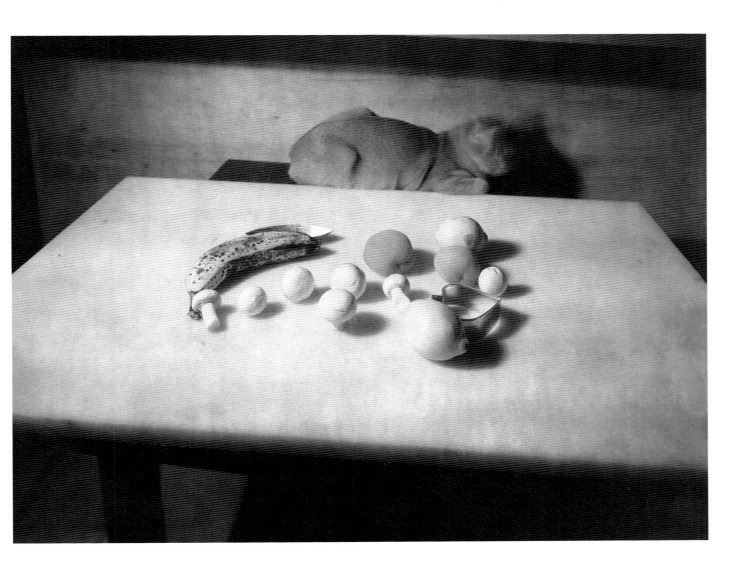

•100• JAN GROOVER, Untitled, 1985

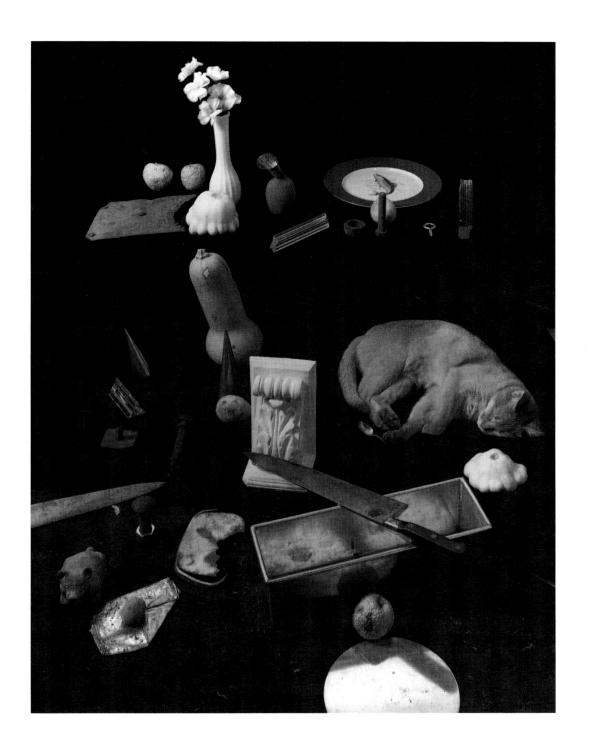

•101• MARCUS LEATHERDALE, *The Familiar*, 1986

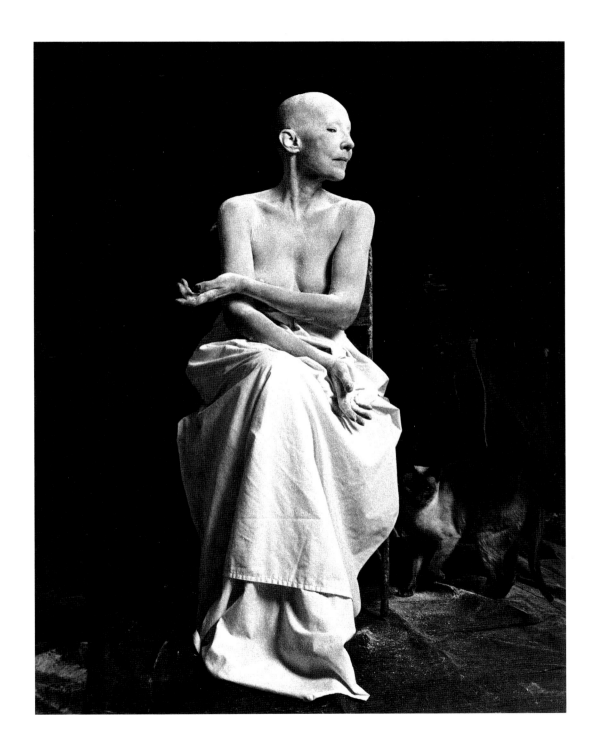

The Cat in the Window

She is called MOUSER because she is fatal to mice.
The vulgar call her CATUS the Cat because she catches
things (a captura) *while others say that it is because*
she lies in wait (captat) *i.e. because she "watches." So*
acutely does she glare that her eye penetrates the shades
of darkness with a gleam of light. Hence from the
Greek comes catus, *i.e. "acute."*

— *from a twelfth-century Latin bestiary*

These words apply to cats, but they could just as well define photographers, for the ability to "write with light" depends fundamentally upon watching, waiting, and penetrating dark, complex subjects without being dazzled by plain daylight.

The earliest photographers knew this well, often spending hours perched, like cats, at the windows of their studios, a tactic then rarely adopted by artists in any other medium. Catlike quickness, agility, and stealth became crucial to photography in its split-second future.

Early camera equipment was so slow that in the 1840s the magazine *Aujourd'hui* satirized the fad of photography in an illustration showing a daguerreotypist hard at work on the rooftops of Paris. Having placed a rock on his camera in order to hold it steady, the cameraman lay down for a nap. The punchline reads: "Talent comes from knowing how to sleep."

In fact, it was not the daguerreotypist who needed to catnap during long exposures, but rather the subject. Problems with motion led the first photographers to shoot architecture, still lifes, unsmiling people (whose heads were held in vise-like clamps), and dogs trained to sit still or to play dead. Cats proved far more elusive.

Thus, a daguerreotype from about 1850 of a cat looking out a window •3• is rare and valuable, despite the fact that the names of the photographer, the owner, and the cat are unknown. This fine symbol of the photographer capturing a clear, still, elevated view seems to have been the result of luck, though dozens of silver-coated plates may have been wiped down and recycled in pursuit of a blur-free image.

The Parisian amateurs Charles Victor Hugo and Auguste Vacquerie (the son and the friend of Victor Hugo, respectively) found a far simpler solution. Their calotype of about 1853 shows Vacquerie's cat, Mouche, fast asleep •9•. Other photographers plied the morbid but honorable Victorian trade of funerary portraiture, yielding at least one portrait of a dead cat.

A calotype by an unknown American photographer depicts a Mrs. Craik and another woman posing with a pet •5•. Nothing is known today about the two women, yet their portrait is charming, thanks to the cat, which lacked ladylike inhibitions, and moved during the long exposure. The two-headed feline freak that resulted is a fine example of the bizarre mutations that unintendedly crop up in photography.

As cameras improved and exposures shortened, feline squiggliness became less of a liability. The British photographer known as H. Pointer, who kept a busy studio in Brighton during the second half of the nineteenth century, was so successful as a photographer of cats that he even made up a business card (*carte de visite*) depicting a cat's head •7•. New Hampshirite Charles Bullard profited similarly, drumming up business with a postcard of a trained cat photographing a kitten, and other crowd-pleasing images.

Their successes notwithstanding, for most nineteenth-century photographers, shooting cats was a waste of time and plates. Not only did the cats refuse to obey or pose, but they also scurried away the moment a camera came into sight. Yet the cats themselves were so photogenic, and pictures of them so desirable, that some photographers nonetheless persistently catered to public taste. Typical of the many photographs of rigid people holding blurry cats or kittens is a daguerreotype •4• from about 1850.

In 1887 Eadweard Muybridge published his no-nonsense series *Animal Locomotion*, in which he had scientifically documented the precise movements of cats, dogs, horses, and other creatures pacing, strolling, and galloping •2•, thus proving once and for all what lovers of cats have always understood instinctively: felines are nearly incapable of moving ungracefully. Although sitting and sleeping cats would continue to be popular subjects, such poses would no longer be de rigueur.

By the 1890s, hand-held cameras and faster roll film made possible spirited, more informal portraits such as the snapshot of a determined little girl clutching a kitten under her arm as she walks •16•. However, most snapshooters continued to copy formulaic portraits of women and girls soberly staring ahead while caressing their cats.

As more convenient equipment revolutionized the medium, serious photographers found they could take risks, stay with a subject, and make many exposures. Significantly, the faster, more lightweight hand-held equipment allowed them to leave the studio, window, or station on the street to become what the French call *flâneurs*.

The word — coined by the writer François Victor Fournel (1829–1894) from the French verb *flâner*, meaning to wander, amble, or stroll — was typically applied to persons with wealth, leisure time, and acute powers of observation. In *Ce Qu'on Voit dans les Rues de Paris* (1858) Fournel wrote that the *flâneur* was both naive and learned:

An intelligent and conscientious *flâneur* observes and remembers everything and can play the greatest role in the republic of art. That man is a mobile and impassioned daguerreotypist who secures the most subtle traces and in whom is reproduced with their changing reflections the march of things, the movement of the city and multiple physiognomies of the public spirit.

Writers such as Emile Zola and Gustave Flaubert were often described as *flâneurs*, and a few early photographers were actually "impassioned," if not "mobile."

With the advent of the Leica camera in 1924, André Kertész, a Hungarian living in Paris, found the perfect tool for his roving, deceptively easy, lyrical vision. Soon he was showing the complexity, theatricality, and freedom of the street, with its diversity of people and animals. In the process he did not abandon the elevated view, as illustrated by his image of a wonderfully wise, old cat looking out a window •37•. At the same time, the strolling, street-smart cat became another of Kertész's metaphors of choice •36•. Others would later find such *flâneur*-like cats, but none with a more rakishly knowing swagger than that in a photo by Elliott Erwitt •54•.

Into the 1980s Edouard Boubat •83•, Henri Cartier-Bresson •51•, and Jean-Philippe Charbonnier •47, 77•, among others, have brought sophistication, elegance, and a light wit to views of cats in windows and cats strolling down city streets and country

lanes. Their problem-free Arcadian worlds in the tradition of the *fête champêtre* seem quintessentially French.

Across the Atlantic, Helen Levitt epitomized the *flâneur* during the 1940s in her street photographs of children and the poor, groups whose gestures tend to be open, awake, honest, and vulnerable because they hide so little of themselves behind public personas. Both the men and the cat in one of her photographs •43• exemplify this naturalness. As James Agee perceptively wrote in an essay included in Levitt's book *A Way of Seeing* (1965), the "overall preoccupation in these photographs is, it seems to me, with innocence — not as the word has come to be misunderstood and debased, but in its full original wildness, fierceness, and instinct for grace and form."

Ambling, ever alert, and highly attuned to mythic potential, Levitt embodied the catlike *flâneur*, master of effortless grace without cunning. But it would take Lee Friedlander to sharpen his claws, quicken his stealth, and liken the photographer to the "one-eyed cat" in "Shake, Rattle and Roll," a song by Charles E. Calhoun which was sung by Joe Turner in 1954:

> Like a one-eyed cat peeking in a seafood store,
> Well, I could look at you — tell you ain't no
> child no more.

When Friedlander chose the title *Like a One-eyed Cat* for a catalogue and retrospective exhibition organized by the Seattle Art Museum in 1989, he was referring, of course, to the single-minded, lusty determination of the "street cat." But he was honoring as well the monocular vision of the camera, which constricts space and otherwise creates distortions rarely found in the works of artists from the years before photography. Friedlander has also cultivated abrupt croppings, exaggerated peripheries, "flash-bombed" foregrounds, and other uniquely photographic snapshooter's "accidents" in order to achieve potent pictorial and metaphorical narrative ends.

However irrational and uncontrolled his results may look at first glance, his ability to bring out the inner truth of contemporary life is uncanny. In this he seems to have taken on the most potent feline trait of all: the cat's legendary visionary, even psychic powers. Thus, the third eye with which metaphysicians see "singly" becomes the eye of the one-eyed cat.

Accordingly, Friedlander's updated version of the cat calmly looking out a window depicts the animal staring through a screen, a symbol of the veil of maya, of illusion •87•. The peacefulness of the image speaks to the photographer's profound awareness that the fascinating, ever-changing play he sees is nothing more than the rippling surface of a drama, which must be penetrated deeply and lovingly until it yields eternal, inner truth.

Kitty Cats, Touchdowns, and Nudes

For the record, valid photography . . . is not cute cats,
nor touchdowns nor nudes. . . .

— *Walker Evans*
from an undated letter in the files of
the Museum of Modern Art, c. 1957

By the 1920s the demand for photographs in newspapers and magazines had led to the emergence of photojournalists who could serve up news, wit, and narrative almost on command. The goal of such photographers could be likened to that of a cat: to stop a bug in midair with a single swat.

A classic of photojournalism appeared in 1925 in the *New York Daily News* — Harry Warnecke's picture of a streetwise alley cat carrying a kitten from her litter across a busy street •38• Because Warnecke arrived long after the kittens had been tucked away safely, he got his picture by taking the kitten back across the street and convincing the policeman to stop traffic once again. The mother cat then reenacted her own script. Similarly, a photograph from the 1940s of a cat exiting a suitcase just in time to escape its fate at the Animal Rescue League looks a bit contrived •39•.

Oddly enough, local Kentucky photographer William Herman Lowe needed no coaxing to get a cat to pose glamorously in sunglasses •27•. It seems that this animal liked to bask in the warmth of the shop window but was sensitive to the light. Its owner, grocer Lon Dodd, obligingly made up a pair of sunglasses, which the cat wore each day with pleasure.

For the most part, however, photojournalists specialize in unstaged vignettes. Masterpieces of the genre balance grace, economy, tension, surprise, and wit, as in Henri Cartier-Bresson's image of a "watchcat" peering out of a brassiere shop •51•, Josef Koudelka's photo of a feline fisherman about to reach its paw into a fishtank •52•, and Elliott Erwitt's shot of a show animal enduring the indignities of competition •75•. In 1955, Edward Steichen's exhibition *The Family of Man* showcased one of Erwitt's most heartwarming photographs — a view of a kitten peeking over the stomach of its pregnant owner. Such images inspired a slew of imitators.

Photographs of cats constitute one of the great clichés of newspapers and magazines, as year after year the public sees endless variations upon the familiar themes of kittens sucking at the teats of dogs, cats nursing mice, cats held tenderly under the wings of chickens, cats reading "Beware of Dog" signs, cats treed by frustrated dogs, cats freed by friendly firemen, and so on. Indeed, the market for such images is so vast that a few photographers even cater to it full time. The late Kamilla Koffler, known professionally as "Ylla," was regularly called whenever an especially endearing or clever shot of cats was required; her images still enjoy wide circulation.

The blatancy of so many photojournalistic images led Walker Evans in 1957 to reply to a letter with the words:

> For the record, valid photography, like humor, seems to be too serious a matter to talk about seriously. If, in a note, it can't be defined weightily, what it is not can be stated with the utmost finality. It is not the image of Secretary Dulles descending from a plane. It is not cute cats, nor touchdowns nor nudes; motherhood; arrangements of manufacturers' products. Under no circumstances is it anything ever anywhere near a beach. In short, it is not a lie, a cliché — somebody else's idea. It is prime vision combined with quality feeling, no less.

And precious few cats crept into his photographs. Those decorating his elegant interiors are most often of the pasteboard variety popularized through countertop advertising cards. Nevertheless, a real-life cat peers down at a sign for a fish store in Evans's collage-like view of a rickety storefront in Beaufort, South Carolina •41•. As the watchful proprietor of the store, the animal complements the bizarre juxtapositions suggested by the other signs — for a public stenographer in residence who could have recorded the words of General Lafayette when he spoke there, and an art school where the painter of the primitive fruit sign could have studied. Notably, the retrospective of Evans's work which was held in New York in 1972 at the Museum of Modern Art featured an alternate version of this photograph, one in which the cat — and along with it the possibility of a laugh — had vanished.

Documenting rural America for the Farm Security Administration, Carl Mydans and Marion Post Wolcott apparently felt far more comfortable with cats •40, 45•. In their Depression-era photographs these animals provided symbolic significance: the colloquialism "feed the kitty" originally reflected the all-too-familiar concern of making ends meet at a time when so many hands were outstretched.

During the same period Helen Levitt caught the contrast between a calm, collected cat sitting behind protective bars and the aggressive, stuttering graffiti on the wall nearby •42•. The creature's meditative mien offers the enlightened message that "this too shall pass."

Even the hard-boiled news photographer Weegee [Arthur Fellig] took time off from gangster murders and bungled burglaries to warm to the sight of a kitty. In 1940, he caught a group of children sleeping with their pet on a fire escape in New York City during a heat wave. In his typically dry style, which was reminiscent of Raymond Chandler, Weegee titled his picture *Tenement Penthouse* •44•. Two years later, stalking the parks at night with his strobe, he found the perfectly matched lady and cat •46•.

Flash and strobe proved useful for much more than recording the casualties of crime, however, and, in the 1940s and 1950s, photographers who captured animals tossed into midair became the darlings of magazine editors. One of the first and best of these artists was Barbara Morgan; in 1942 she photographed a ball of swirling kittens falling through the air •62•. The subject suited Morgan, for as a well-known photographer of the dance she often studied ballerinas emulating feline movements in the difficult step known as the "pas de chat." (Her images were not, in fact, documents of actual dances but variations evolved with the help of the dancers.)

Twenty-three years later, choreographer George Balanchine coaxed his pet, Mourka, into a grand jeté for photographer Martha Swope. The editors of *Life* magazine applauded, calling this cat "a furry entrechat if there ever was one" •65•. Balanchine himself said of Mourka: "At last! A body worth choreographing for!"

Islamic legend holds that the cat's ability to jump or fall great distances yet land on its feet unharmed came as a gift from Muhammad. The prophet showed his appreciation of his pet Meuzza by passing his hand over the cat's back three times in order to grant it perpetual immunity from the danger of falling. Whatever the case, falling and "flying" cats provide some of the liveliest — and best-known — photographs in the genre.

In 1948 Philippe Halsman collaborated with Salvador Dalí on *Dalí Atomicus* •64•, which was

inspired by Dalí's painting *Leda Atomica*. Explaining the latter work Dalí said: "Because in an atom everything is in suspension, the electrons, neutrons and other junk . . . and since I live in an atomic era I have to paint everything suspended in space."

According to Halsman, Dalí's original plan was to "take a duck and put some dynamite in its derrière. When the duck explodes, I jump and you take the picture." When Halsman protested on legal and humane grounds, Dalí decided to toss cats instead. Coordinating the throwing of cats and water with Dalí's jump was no easy task. Halsman borrowed three cats and hired four assistants, one of whom threw the water while the other three tossed the animals. Attaining a successful photograph took twenty-six throws, twenty-six wipings of the floor, and twenty-six searches for the cats, which fled the scene as quickly as possible each time. Halsman liked the episode — and the resultant photograph — so well he told the story in almost all his books.

Magazine assignments have led to thousands of celebrities being photographed with their pet cats. Among the most remarkable of these pictures is Edward Steichen's interpretation of the rather feline playwright Noel Coward, who stands haughtily in dapper splendor while a sculpture of the Egyptian cat god Bastet looks on •68•. Interestingly enough, the sculpture was not part of the original conception but was montaged later — the perfect affectation in Coward's chic, too-much-is-not-enough world. It was stagy, yes, but no photograph could have been truer — at least to the playwright's affected persona. In the next few decades more casual, more natural portrayals would come into vogue.

Leslie Gill's portrait of the Italian painter Franco Gentilini, his daughter, and her tomcat is lovely for the ways in which its painterly mottling and illusion of rich, antique patina set off the modern, informal pose •61•. Seemingly simple, almost snapshotlike, this picture is reaction both to Steichen's work and to the "new vision" of Dora Kallmus, known as Madame d'Ora, who in tightly cropped, boldly framed, closeup portraits sought striking contrasts of dark and light, and of flesh and fur. Among her portraits is one of Tsugouharu Foujita (1886–1968), a Japanese-born French painter renowned for paintings, drawings, and watercolors of cats •70•.

Scores of celebrity cat books have been published which feature the faces of both the animals and their always-loving masters focused front and center. The creators of such images could learn something from Sir Cecil Beaton's photograph of Mrs. J. J. Astor. Although her face does not appear, her clinging hands and swaddled cat reveal multitudes about her needy, overprotective nature •74•.

The lack of cats in an image can be even more telling. For instance, August Sander's encyclopedic portrait of the German people — which he gathered specimen by specimen from all strata of society — includes many subjects standing somberly with their dogs. Curiously the only cat pictured in this oeuvre is Sander's own pet, Mucki, which is seen sleeping in his studio •57•. Could the absence of cats, which are said to possess psychic powers, reflect a voluntary blindness during the years of the Weimar Republic? Or did cats, as independents that scoff at orders and do only as they see fit, stand in mute reproach of those who would dominate and control others or kowtow to authority? Surely cats existed in Germany, but Hitler loathed them, so they do not often appear in straight photographs of that country in the 1930s and 1940s.

Despite the presence of so many subtle, multi-layered photographs, Walker Evans's exhortation has led most serious contemporary photographers to pussyfoot around not only the subject of cats, but those of touchdowns, nudes, and motherhood as well. Not all photographers have agreed, of course. The French have often photographed cats and nudes together •77, 78•, and the American Dan Weiner dared to photograph a cat near a beach •49•.

As for contemporary photographer Tony Mendoza, the taboo has simply been good for a laugh. More than any other photographer, Mendoza has succeeded in portraying a cat with a full-fledged personality •95–97•. His Ernie is a wily operative on the prowl, as funny and endearing in real life as Krazy Kat and Felix are in cartoons. Variously sly, sleepy, gleeful, preening, nosy, snarling, and circumspect, Ernie seems both winningly human and absolutely feline. Since no other photographer has so perfectly captured the essence of "cat," Mendoza must have stalked and perceived with the animal's own curious, playful vision.

Even so, most curators still regard photographs of cats with the same disdain accorded fiery sunsets, cuddly babies, and other camera-club clichés. Nowhere has this been truer than in the critical attention given the work of Edward Weston. As Imogen Cunningham's portrait of Weston (1945) shows, there are uncanny similarities between cats (his most faithful friends) and pieces of driftwood (the subject of some of his best-known images) •60•. Weston's twenty-odd caterwauling and carousing domestic shorthairs and longhairs became the subject of his book *The Cats of Wildcat Hill*, a series

of images that Weston described excitedly in 1944 in a postcard to his sister Mary Weston Seaman as "a new epoch in my photo life." The work was produced during the war years, when the California coast, which he so loved to photograph, was closed. Restricted as well by the onset of Parkinson's disease, Weston stayed home to focus on his cats, illuminating their sultry stretches, their shapely curves, and every hair of their luxurious coats. As the unpretentious Weston wrote to his sister: "No fancy cats allowed, just plain 'alley cats.'"

Despite the sheer number of these photographs and despite Weston's own evident regard for them, most critics and curators regard them as sentimental embarrassments. Hilton Kramer, who flushed out a whole new area of critical inquiry with his essay "Edward Weston's Privy and the Mexican Revolution" (1972), disdained even to mention Weston's "cathouses." Photographic historian Beaumont Newhall — attempting to protect his good friend Edward from his own instincts — did not include a single photograph of cats in his retrospective of 1986.

One thinks of the aristocratic Parisian François Augustin Paradis de Moncrif, author of *The History of Cats* (1727), the first book on the subject and such a popular success that his snooty intellectual friends and enemies made him come to wish he had never written it at all. Parisian newspapers were flooded with witty, sometimes tasteless verses about the book, and Moncrif could go nowhere without cringing at the ignominious taunt: "The velvet paw, the velvet paw. Pussy pussy."

The Velvet Paw

The love of dress is very marked in this attractive animal. He is proud of the luster of his coat and cannot endure that a hair of it shall lie the wrong way.
— *Champfleury [Jules Fleury-Husson]*
Les Chats (1870)

Champfleury's words describe the cat, but they could equally well describe self-conscious, art-for-art's-sake photographers. Attempting to prove the artistry of the medium, such photographers painted out all evidence of its sharp, mechanical nature to such a degree that their images hold the warm, rich appeal of a pampered house cat's luxuriant, well-licked coat •1, 31•. At their worst, such photographs are pseudo-artworks, beauty-parlor affectations. But at their best, they carry the power and beauty of feline paws — retractable, sharp-clawed daggers sheathed in soft velvet.

A lovely example is Frank Eugene's portrait of Frau Ludwig von Holwein •30•. By incorporating a painting of a plump and boldly patterned black-and-white cat with its head turned slyly toward the viewer, Eugene provided a startling three-dimensional illusion, an additional reference to art, and a reminder that, even as late as 1910, photographers had trouble trying to capture the cat's mercurial temperament.

Art photographers of the late nineteenth through the early twentieth century simply did not depict cats playing with plants and flowers as did their contemporaries the French Impressionist painters Pierre Auguste Renoir and Pierre Bonnard. With their flighty, often unpredictable personalities, cats made excellent subjects for the Impressionists, who were entranced with fleeting glimpses of color and light, but the animals were poor subjects for photographers. Because color was rarely an option and equipment was not easily adaptable to quickly moving subjects, turn-of-the-century photographers strove for art through elegant, quiet poses in which the cats lay or sat still.

Generally these artists sought to catch the cat's elusive essence through soft-focus techniques that gave the effect of moonlight or of a veil. Edward Steichen's *The Cat* of 1902 is a fine example of his early, melancholic style •1• This asymmetrical period composition was based on the then fashionable interest in pattern and *notan*, the Japanese term for the interplay between light and dark.

Within a few decades such drawing-room portraits of cats — with their every hair neatly in place — would become commonplace among pictorialists participating in camera clubs. Helen M. Becht was typical of this era, producing decorative and winsome portraits of cats which emphasized unexpected conjunctions of form, light, pattern, and texture •31•. Such images suggest Charles Baudelaire's perfume-loving pets, which wandered about his house on velvet paws, as described by Théophile Gautier in his preface to *Les Fleurs du Mal* (1857).

In 1950, Sir Cecil Beaton, master of the success-in-excess school of photography, theatrical set design, and interior decoration, took pictorialism to a new high with the help of luxuriously mottled coleus leaves and tabby-cat fur •79•.

Thirty years later, Jan Groover photographed her pet Livia, visually exploiting the cat's fluid form, velvety fur, and capacity to blend and merge with her background and to echo the forms of the bananas, mushrooms, cookie cutters, and other objects in her still-life repertoire. Like cats themselves, these still lifes are visual, sensual, mysterious, and self-sufficient •99, 100•.

Fashion arbiters have long compared the ideal woman to a sleek, elegant, sometimes voluptuous feline. In the 1950s the editors of *Harper's Bazaar* saw no moral conflict when Louise Dahl-Wolfe photographed model Mary Jane Russell holding a silken pet in her arms while posing sensuously on the skins of its wilder relative, a leopard that had been killed for its fur. Although the woman seems oblivious to such connections, it may be no accident that the cat's eyes seem quite "spooked" •72•.

Like most fashionable women of that decade, Russell probably learned to charm men by affecting the winning ways of a kitten. Accordingly, in another image by Dahl-Wolfe, the model coyly shoos away a cat that is scratching her Balenciaga gown, while a second cat looks on admiringly •71•. In Richard Avedon's photograph of the same period, the fluff-ball Persian provides a striking contrast to the undulating paths of model China Machado's cheekbones, dress, and arms, and the ravishing sweep from Suzy Parker's jawline across her gown, but there is a touch of chic urban narrative as well. This picture reveals young Avedon at his best, tempering obvious artifice with the apparent authenticity of a Paris bar •73•.

Such photographs are rare, for few art directors and fashion photographers have had the patience to direct feline models, who consider it a point of self-respect to do precisely as they please. A cat asked to lap milk for a spread on the latest in "milk white" fashions may well mock the inanity of the task by chasing its tail. Should the theme "letting sleeping cats lie" be chosen for a lingerie ad, the cats will very likely scurry away, leaving the women alone to show off their silky skin and shimmering satins.

Cats' notorious unwillingness to perform on command has also unraveled many an art photog-rapher's attempt to stage genre scenes imitating paintings of the sixteenth through the nineteenth century. Oscar Gustave Rejlander is one of the few who succeeded. In *The Milkmaid Feeding the Cat* (1855), his glowing milkmaid, with her silver pail and pet cat, recalls numerous painted idealizations of eighteenth-century peasant life •10•. Rejlander's control of chiaroscuro is quite unphotographic, the result of careful staging, lighting, makeup, and even photomontage.

More than fifty years later, in 1913 and 1914, the Dutch photographer Richard Polak paid homage in an unusual way to paintings by the masters Jan Vermeer, Pieter de Hooch, and others, painstakingly replicating their oeuvre photographically. To this end, he acquired a seventeenth-century house in Amsterdam, as well as theatrical costumes, props, models, and — somehow — cooperative cats. His book *Photographs from Life in Old Dutch Costume* includes *Merry Company* •33•. How he trained his cats is not known, but had he lived in present times he would surely have been the trainer of Morris, the chubby, finicky marmalade tom that appears in television commercials for 9-Lives cat food.

Few other art photographers have gone to the length Polak did, although many stud their works with references to art history, or else they contrive artlike effects. In 1931 James Van Der Zee plopped glasses on an obliging feline and named his photograph *Smart Cat* •32•, a revamp perhaps of Jan Steen's charming anecdotal painting *The Cat's Reading Lesson* of 1650.

More elaborate costuming of cats has proven difficult. Few photographs rival Gustave Doré's illustrations of *Puss in Boots* or offer the moral lessons of Aesop's or La Fontaine's fables. Nonetheless, feline mascots were popular, as numerous picture

postcards from the turn of the century through the 1950s attest •21•.

Costuming of cats was not the bent of the Bauhaus artists of Weimar Germany, but in their technological experimentation they depicted the animals in guises never seen before — in one instance even reversing a cat's stripes in order to showcase its shining coat •55•. In *Von Material zu Architektur* (1929 [*The New Vision*, 1940]) Moholy-Nagy wrote of this photograph — which is variously called *Negative Cat* and *The Texture, the Feel of a Cat*: "In any photography, the white spaces always produce an 'active' effect through the reversal into the negative; the shape of the cat's body, normally immediately recognizable, is eliminated and the internal pattern of the fur becomes the lambent principal feature of the composition."

The freethinking, freewheeling experimentation of the Bauhaus also led to Oscar Nerlinger's cartoonlike vision of a cat •56•. By placing objects directly on light-sensitive paper and waving wands of light, he created an image that was liberated from the world of appearances, that went beyond mundane observation into the realm of poetic invention.

Wanda Wulz's self-portrait of 1932, *My Cat and I* •69• also exemplifies Moholy's observation (in *Vision in Motion*, 1946) that superimpositions — which he also termed *photo plastics* — were the way to "transpose insignificant singularities into meaningful complexities, banalities into vivid illuminations." Today's viewer may see something far less complex, for Wulz's furry face recalls the hit Broadway play *Cats* or one of its many predecessors in ballet and theater (some of whose cat-costumed actors and actresses were photographed by Brassaï in the late 1940s as part of his roamings into the haunted and haunting world of Paris at night). When Wulz made this image, however, her vision was new, striking, and reflective of the artistic aspirations of an entire era.

Despite the difficulties of enlisting feline help, art photographers — at least those who call themselves artists rather than photographers — have employed cats as models far more often than they have dogs. The most obvious explanation is aesthetic: they appreciate the cat's incomparable grace, beauty, and elegance.

Writers since the Symbolist period have compared the sensitive, refined temperament of the artist to the exquisite delicacy of the cat's nervous system. Going a step further, in 1920 a writer for *The Nation* posited the arrival of a new cultural age: "To respect the cat is the beginning of the aesthetic sense. At a stage of culture when utility governs all of its judgments, mankind prefers the dog."

The Tiger at the Hearth

*God made the cat in order to give us the pleasure
of caressing the tiger.*

— *Fernand Méry*
Le Chat *(1966)*

From the 1840s to the 1860s, dogs far outnumbered cats in photography. Most probably, this was because cats were not common as household pets before the Crystal Palace Exhibition in London in 1871, during which Harrison Weir, a popular illustrator of cats and the president of the English National Cat Club, mounted the first official cat show. In 1889, Weir published *Our Cats and All About Them* in both England and America. The first English book on cat care had been published in 1856, and just half a century earlier Thomas Bewick's *A General History of Quadrupeds* had described only four types of cats but thirty-six types of dogs.

Though cats were still less popular pets than were dogs, amateurs and professionals photographed them fairly frequently from the 1870s on, depicting them almost always in the company of women and girls. Cats were associated with beauty, gentleness, sensitivity, grace, and charm, all of which were considered female virtues. Primitive painters of eighteenth- and nineteenth-century America often rendered girls standing primly in their best dresses as they held their cats and kittens. Although many of these were somber in tone and stiff in pose, the children usually held their pets tenderly.

During the first decade of the twentieth century, when homemade photographic postcards were all the rage, snapshooters sent their film to Kodak, which sent prints back in postcard form, ready for mailing all over the world. Predictably, many photographers capitalized on proven formulas of portraiture showing felines and females. Far rarer are postcards of men with cats. Two examples include an old man who, though relegated to a wheelchair, still takes pleasure in his gentle pet •19•, and a man taking a rest from his routine by playing with a group of cats •24•. In contrast, scores of photographs from this period depict men and boys engaged in activities with canine companions.

Postcards clearly illustrate the Victorian theory that cats could serve in teaching little girls to be clean, strict, yet loving disciplinarians. Playing mother to kittens — like playing with dolls — provided practice for marriage and motherhood. Thus, a postcard is revealingly captioned *Poor Kittie* [sic] *Getting a Scolding* •15•. One might wonder if the popular Currier & Ives lithographic print *My Little White Kitties Into Mischief* was hanging in the little girl's parlor. Certainly, children of that era and earlier ones had been educated with illustrated stories about cats. In the 1730s William Hogarth had produced pictures with "modern, moral subjects" for the purpose of teaching the virtues of middle-class values. For him and his many eighteenth-, nineteenth-, and early-twentieth-century followers, the family cat, which was both pet and a worker, exemplified morality.

Carl Van Vechten — whose *The Tiger in the House* (1920) is still considered a classic — argued in his book that Walt Whitman was wrong when he said of cats that "not one is demented with the mania of owning things." Cats have a finely developed sense of property rights, which they are willing to protect and which some honor by not slinking into the homes of others. Within a home, a certain chair almost always becomes feline property, forbidden to both dogs and humans. And, of course, cats

select warm spots by the hearth, stove, radiators, and windows.

Victorians admired the cat's ability to alight on a table full of breakable objects without disturbing anything. That this proof of "civilization" is, in fact, something else altogether — a genetic link to the stealth of the big cats — is not something that the genteel bourgeois of that era were likely to have admitted.

With few exceptions, nineteenth- and early-twentieth-century photographers of cats emphasized their gentleness and beauty. This was especially true of turn-of-the-century art photographers in Alfred Stieglitz's circle; they often photographed women and girls with cats, but rarely photographed dogs. Gertrude Käsebier's family portrait of angelic children with their ordinary cat •29• presents a particularly fascinating case. She had to lop off a corner of this blessed vision when she discovered that her grandson was picking his nose: Making the best of the L-shape that remained, she penned Christmas greetings in the gap.

Decorum was everything, and images from this period rarely show cats prowling barnyards and rooftops, hunting and killing rodents, or scavenging in garbage bins. One reason for this is symbolic: proof of American economic progress lay in the existence of indolent parlor cats, which no longer had to earn their keep by mousing. Accordingly, owners spoke proudly of their haughty aristocratic cats, which refused to enter their houses by the servant's door, tippled only the finest brandy, and dined daintily on esoteric gourmet dishes.

After reading scores of books on cats, Van Vechten wearily concluded that "affectionate, intelligent, faithful, tried and true are some of the adjectives [owners] lavish indiscriminately on their darling pets. . . . You'd think they spent nine lives caring for the sick, saving children from burning buildings and helping Mrs. Jellyby make small clothes for the heathen in Africa."

Unlike their owners, the cats themselves were direct, announcing their hunger, lust, and other needs, desires, and opinions all with no thought for decorum. These plain declarations show up infrequently in photographs. A clear picture of a tomcat's randy potential •61• could only be a modern image. Still, a few nineteenth- and early-twentieth-century barnyard scenes exist, showing that cats were not solely well-bred purebred occupants of parlors. A strange example by an unknown American features an incongruously large, cowlike cat in a home-made, irregularly cut circular format •22•. John H. Billinghurst's stereograph *Tabby at Breakfast* (1905) shows a pragmatic cat drinking milk squirted straight from a cow's udder •23•.

In a rare photographic reference to the feline's predatory nature, a cat ogles five rabbits slung on a hunter's rifle •25•. This humorous vignette updates the narrative of an early-eighteenth-century still life by Jean-Baptiste-Siméon Chardin, who depicted a cat relishing the sight of a dead pheasant and rabbit that lay in front of a shiny, new cooking pot. There is no reference, of course, to the ripping and tearing of flesh. Indeed, all is "happy and nice" just as in the nursery rhyme:

The world is so full of a number of mice

I'm sure that we all should be happy and nice.
To curb the tiger in the cat, many owners put bells around the necks of their pets so the jingling would warn birds to fly off •11•. Somehow, proper, prosperous Victorians and Edwardians, who ate copious amounts of beef, chicken, mutton, partridge, and other meats at every meal, could not stomach the

innate carnivorousness of cats. To make hypocrisy the sole explanation is simplistic; popular illustrations of cats pouncing on rats, flagging down birds or butterflies, and jumping from tree to tree abounded at the turn of the century. However, for most photographers of the time, such speedy activities were simply beyond their technical ken.

Despite the paucity of early photographs of felines hunting, the fact remains that cats suited the Victorian work ethic, and mousing continued to be valued by householders, shopkeepers, and farmers until the predators were replaced by snap traps and strychnine. Long before such "progress" occurred, Arnold Genthe wittily noted the aloof independence of the species when he provided his photograph *French Quarter Patio with Cat* (c. 1925) with the witty alternate title *Boss of the Fish Dealer's Court* •35•. Darius Kinsey made it clear that the kitten in his photograph was very much loved by its owner, however useful it might also have been in ridding the pantry and supply room of rats •28•.

Ironically, now that pet cats function less as predators, they are more often photographed in that guise, primarily by photojournalists and amateurs enchanted by the grace with which the animals swat and pounce. To this cliché has been added yet another, as cat-loving magazine editors scoop the competition with pictures of the occasional cat that is willing to cradle and cuddle mice. None of these is more startling than a photograph by Donald McCullin, a coup that could inspire a tabloid headlined *Man Eats Mouse, Cats and Mice Look On.* The actual title of this picture is the more sober *Snowy, the Mouse Man, Oakington, Cambridgeshire* •53•. McCullin met a "veddy" British eccentric at a carnival, "chatted him up," followed him home, and finally captured his picture.

Whether worker or observer, active or indolent, the household tiger sometimes leaves the hearth for the free life of rooftop and alley. Emile Zola wrote about this in his short story "The Paradise of Cats" and Booth Tarkington's cat Gipsy forsook the comforts of the fireside and the affections of a proper little girl for the uncertain pleasures of freedom and the hunts and power plays of midnight maraudings in the feline underworld. With the advent of fast, small cameras in the 1920s, the sight of cats slinking down alleys, crawling down walls, leaping over rooftops, and just strolling down the street became ever more commonplace in photography.

Such images suggest the wild, untamable essence of the cat, which has never been lost and probably never will be. Like its royal relatives the lion and tiger of the jungle, *Felis domesticus* harbors strong, primitive instincts that survive to be awakened whenever called.

The Black Cat

. . . chat mystérieux,
Chat séraphique, chat étrange. . . .

— Charles Baudelaire
"Le Chat," from Les Fleurs du Mal (1857)

Through the ages cats have been both worshiped as gods and tormented as devils because of their luminous, reflective, all-seeing eyes. The Egyptian word for cat, *mau*, means "to see," and for the ancients seeing did not mean perceiving worldly facts alone. In ancient Egypt cats were considered psychic and were consulted as oracles. Never again would they be as venerated as they had been in that culture.

By the Middle Ages, cats were alternately blessed and cursed. Medieval illuminators drolly depicted the creatures in the margins of their manuscripts spinning yarn or catching balls of wool, or showed them as incarnations of the corn spirit, the symbol of growth and eternal life. But by the late medieval period and the early Renaissance, the cat was seen as a symbol of evil, an enunciator of danger, an omen of ill tidings, and a companion of witches.

It was not until the sixteenth century that artists divested the cat of its alternately blessed and evil role, and began depicting the familiar animal of today — a natural creature in a domestic setting which cuddles, naps, mouses, sips milk, and plays with string. In time the clichés became so unbearable that art historians sniffed, turned up their noses, and hightailed it away.

Photographic curators have dutifully joined the pack, failing to see that the cat's connection with the occult should accord it proper respect. The very origins of photography are, after all, linked with alchemy. Giovanni Battista della Porta stirred his deadly brews, shaped his shards of glass, and in 1558 announced the creation of the camera obscura — although Leonardo or any of several others may have been the actual inventor. Even so, it took a few more centuries before real photographers hid under black focusing cloths, protected their magic secrets, and, according to widespread primitive belief, stole human souls. At the same time, cats began serving photographer-alchemists as both muses and subjects.

It might be stretching interpretation to say that the souls have been taken from the unfortunate women in one daguerreotype (c. 1850), but their intelligence certainly seems dimmed, and the girl gripping the cat seems utterly possessed •4•. Such results were by no means unusual in the daguerreian dark ages.

During the next 150 years images of two-headed cats •5•, cats with reversed markings •55•, cats created with magic wands and manufactured light •56•, and a cat with swiveling head worthy of *The Exorcist* •97• emerged from photographic studios. Such creatures would be welcome guests at witches' sabbaths — or even stirred into the brew.

What should one make of the cat that lies dead or sleeping near the knives and other odd objects in Jan Groover's still life •100•? When asked for an artist's statement the photographer typically replies that "formalism is everything," yet the picture suggests that Groover stocks the essential ingredients for a potion drunk by medieval occultists who hoped to attain clairvoyance and to prevent blindness. Would-be artists of that time were known to burn the heads of cats to ashes, then three times a day blow the dust into their eyes, chant in Latin, and walk backward.

Other photographers have depicted cats as

the witch's companion, or familiar, a role satirized in Marcus Leatherdale's photograph *The Familiar* (1986), starring a chic New Yorker with shaved head, Roman costume, and sauntering Siamese •101•. Then, too, there is something of a "familiar" quality to Lee Friedlander's view of Martha Ryther and her serene black cat •88•. In Friedlander's work, as in that of Jill Freedman •76•, Duane Michals •94•, Nicholas Nixon •92•, Anne Noggle •90, 91•, and Sage Sohier •93•, cats join seemingly lonely people or dysfunctional families as metaphors for aloofness, alienation, emotional remoteness, and wistfulness. These animals are modern-day familiars, faithful friends to powerless witches and warlocks. Such photographers are almost psychic in their ability to intuit these connections, and their images nearly always defy full, rational explanation.

Whether photographing people or landscapes, many photographers have consciously or unconsciously been drawn to smears, blurs, and distortions that from the right vantage point coalesce into human heads, skulls, figures, and other potent signs and symbols. Beaumont Newhall relates that Edward Weston was less than pleased when László Moholy-Nagy insisted on turning his photographs every which way in order to discover hidden and fantastic faces. Yet the frequency of such anamorphic forms in Weston's own oeuvre suggests they were not entirely accidental. The photographer's pets in *Cats on Steps* (1944) seem to be watching a magic picture show of grotesque faces reflected in the window •59•. The Surrealists, who actively courted and contrived similar special effects, would have been entranced with such a find.

It was the cat's unusually fine nervous system, its "electricity," that made it so useful in confirming the visions of witches and sorcerers. Sensitive and susceptible, these creatures perform apparent miracles — such as reckoning time, forecasting the weather, and foreseeing earthquakes, shipwrecks, and bombs — for everyday people as well.

The photographer Arthur Fellig seemed truly psychic in his ability to arrive at the scene of a crime well ahead of police, reporters, and other ordinary mortals. Boasting that he was a human Ouija board, he named himself "Weegee" and called his business the Weegee Psychic Freelance Photographic Studio. He answered the phone with the words "This is the fabulous Weegee speaking," and was convinced that his photographs spelled out eerie truths that were indescribable, inimitable, and incomparable.

Weegee was feline in other ways as well. He slept by day, hunted by night, inexplicably appeared and disappeared, and possessed the cat's legendary ability to see in the dark — at least with the help of flash or infrared film. He was not a "shape shifter," however, unless, when he left his body in 1968, it was to be reincarnated as a cat.

Shamans believe that cats are not always in their true shapes, that they, in fact, are shape shifters, able to turn in an instant into women or other beings. Such a transformation was recorded in Wanda Wulz's *My Cat and I* •69•. True shape shifters would have stalked the night as a cat, made merry, then returned to bed in the morning as women, as is often told in folklore, but in lieu of magic drinks or salves Wulz preferred the transformative technique of photomontage.

In contemporary photography, shape shifting most often takes the form of peculiar photographic distortions, as in the spooky, looming feline in an image by Anne Noggle •90•. Just as often *space shifting* is the game, as with John Kimmich's photo-

graph of the Alhambra. In this picture a cat — fully at home in the sacred site — walks by, oblivious to the shimmering walls and foliage, which seem to move back and forth in reversal of known natural laws •86•.

Similar in mood is a photograph taken in 1915 by Eugène Atget, who, recording the streets, buildings, and monuments of old Paris, used outdated equipment that rendered moving cats as a blur. Although this record might appear technically flawed, the ghostly portrayal of the cats, coupled with the living, breathing quality of both stonework and greenery, heightens the haunting spirituality of the scene. On a figurative level the ghosts provide tangible reminders that this Parisian era would soon be gone •34•.

Today, Elaine Mayes is exploring the issue of the cat's legendary chameleon-like quality, its apparent ability to appear and disappear, and to move unobtrusively through different environments. In *Tweede* •81•, Mayes poses the possibility that her pet has magically dematerialized into the pattern and texture of an oriental rug. Another of her cats glows almost invisibly amid the luminous white leaves of a hedge •80•. Although these photographs reflect her study of the formal issues of light on light and pattern on pattern, the special enclosures, marked passages, and beams of light intimate sacred spaces and magic circles. Clearly, the cat's age-old reputation as a keeper, and even creator, of mysteries has been revived.

Meanwhile, photographers providing "occult" images to newspapers and magazines tend to be ever more obvious, regaling readers year after year with pictures of black cats walking under ladders, yowling at the moon, and peering up at the unlucky number thirteen. Such Halloween humor is good for a laugh but predictable and ultimately regrettable, for it proves the failure of so many photographers to distinguish between "looking" and "seeing."

Looking is a search for something that is already known; conditions and expectations based upon past experience invariably color the perception of truth. Seeing, in contrast, rejects all ideologies, theologies, and ideas in favor of full, open experiencing in the here and now. It is knowing without knowledge — the way of the cat — and the way of all great photographers.

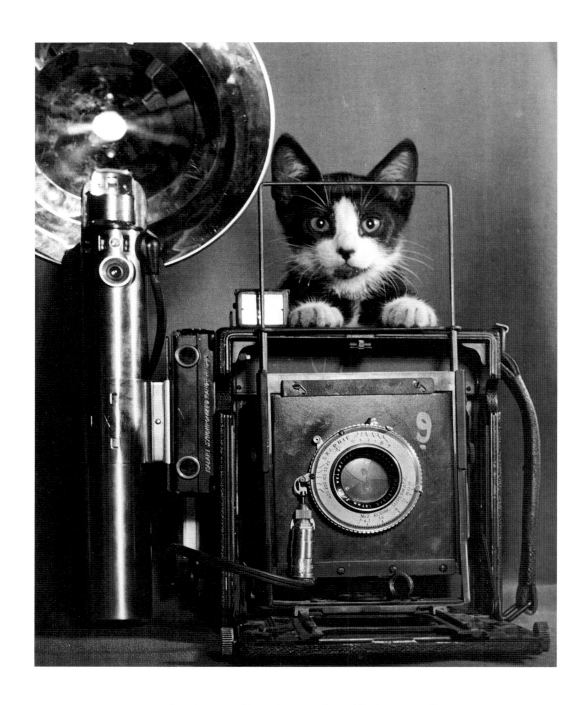

•102• Photographer unknown, *Cat with Camera*, n.d.

LIST OF PLATES

1 • EDWARD STEICHEN (American, b. Luxembourg; 1879–1973)
The Cat, 1902
Gum platinum print
8 × 5 in.
Collection of the Royal Photographic Society, Bath, England. Courtesy of Joanna Steichen and the Julian Bach Literary Agency.

2 • EADWEARD MUYBRIDGE (American, b. England; 1830–1904)
Cat Galloping (.028 seconds), One Stride in 13 Phases, 1887
Collotype
8¼ × 12⅜ in.
Courtesy of the International Museum of Photography at George Eastman House.

3 • Photographer unknown (American)
Untitled, c. 1850
Daguerreotype
2¾ × 2½ in.
Courtesy of Uwe Scheid Collection.

4 • Photographer unknown (American)
Untitled, c. 1850
Daguerreotype
2¾ × 2½ in.
Courtesy of Robert Mann, fotomann inc.

5 • Photographer unknown (American)
Mrs. Craik (and Sister?) Holding Cat, n.d.
Calotype
4⅝ × 3¾ in.
Collection of the Art Institute of Chicago, Harriet A. Fox Fund, 1970.852. Copyright © 1989 Art Institute of Chicago. All rights reserved.

6 • THOMAS RICE BURNHAM (American, 1834–1893)
Untitled, c. 1860
Carte de visite
3½ × 2¼ in.
Courtesy of Roberta DeGolyer.

7 • H. POINTER (British)
Untitled, c. 1870
Carte de visite
3½ × 2¼ in.
Courtesy of Rodger Kingston.

8 • Photographer unknown (European)
Untitled, c. 1865
Albumen print
10 × 8 in.
Courtesy of Rodger Kingston.

9 • CHARLES VICTOR HUGO (French, 1826–1871) and AUGUSTE VACQUERIE (French, 1819–1895)
Vacquerie's Cat, Mouche, c. 1853
Calotype
Courtesy of the Musée d'Orsay, Paris. © R.M.N.

10 • OSCAR GUSTAVE REJLANDER (British, b. Sweden; 1813–1875)
The Milkmaid Feeding the Cat, 1855
Composite albumen print
8½ × 6 in.
Courtesy of the Gernsheim Collection, Harry N. Ransom Humanities Center, University of Texas at Austin.

11 • THOMAS EAKINS (American, 1844–1916)
The Cat in Eakins' Yard, c. 1880–1890
Platinum print
4¾ × 2⅝ in.
Courtesy of the Hirshhorn Museum and Sculpture Garden, Smithsonian Institution. Transferred from Hirshhorn Museum and Sculpture Garden Archives, 1983.

12 • THOMAS EAKINS (American, 1844–1916)
Amelia C. Van Buren, c. 1891
Platinum print
3⅜ × 5⅜ in.
Courtesy of the Philadelphia Museum of Art, Given by Seymour Adelman.

13 • Photographer unknown (American)
Untitled, c. 1885
Albumen print
5 × 7 in.
Courtesy of Rodger Kingston.

14 • Photographer unknown (American)
Tommy Morgan, c. 1910
Picture postcard
5½ × 3¼ in. (oval)
Courtesy of Priscilla J. Barclay and Kenneth C. Burkhart.

15 • Photographer unknown (American)
Poor Kittie Getting a Scolding, 1906
Picture postcard
5½ × 3½ in.
Courtesy of David Freund.

16 • Photographer unknown (American)
Helen, c. 1890
Gelatin printing-out paper
3½ in. (diameter)
Courtesy of Priscilla J. Barclay and Kenneth C. Burkhart.

17 • Photographer unknown
Cat Pushing Cart, n.d.
Gelatin silver print
8 × 10 in.
Courtesy of the Bettmann Archive.

18 • Photographer unknown (American)
Untitled, c. 1910
Picture postcard
5½ × 3½ in.
Courtesy of David Freund.

19 • Photographer unknown (American)
Untitled, 1909
Picture postcard
5½ × 3½ in.
Courtesy of David Freund.

20 • HARRY WHITTIER FREES (American)
The Rotograph Company
A Sample Lot, 1905
Picture postcard
3¾ × 6½ in.
Courtesy of Rodger Kingston.

21 • HARRY WHITTIER FREES (American)
The Rotograph Company
The Pride of the School, 1905
Picture postcard
5½ × 3¼ in.
Courtesy of Rodger Kingston.

22 • Photographer unknown (American)
Untitled, c. 1890
Gelatin printing-out paper
3½ in. (diameter)
Courtesy of Priscilla J. Barclay and Kenneth C. Burkhart.

23 • JOHN H. BILLINGHURST (American)
Tabby at Breakfast, 1905
Stereograph
Each image 3 × 3 in.
Courtesy of the Library of Congress.

24 • Photographer unknown (American)
Untitled, c. 1910
Picture postcard
5½ × 3½ in.
Courtesy of David Freund.

25 • Photographer unknown (American)
Untitled, c. 1910
Picture postcard
3½ × 5½ in.
Courtesy of David Freund.

26 • Photographer unknown (American; family of
William Clift)
Violin Child, c. 1930
Modern gelatin silver print
7¼ × 9 in.
Courtesy of William Clift. Copyright © 1985 William Clift.

27 • WILLIAM HERMAN LOWE (American, d. 1988)
Untitled, c. 1920
Gelatin silver print
3½ × 4½ in.
Courtesy of the Kentucky Library, Western Kentucky
University.

28 • DARIUS REYNOLD KINSEY (American, 1896–1945)
Logging Camp Cooks and Helpers, Bloedel-Donovan
Logging Camp, Alger, Washington, September 12, 1918
Gelatin silver contact print
11 × 14 in.
Courtesy of the Whatcom Museum of History and Art,
Bellingham, Washington, D. Kinsey Collection.

29 • GERTRUDE KÄSEBIER (American, 1852–1934)
The Artist's Daughter, Hermine, and Her Children at Tea,
1911
Platinum print
8⅝ × 8⅛ in. (maximum height and width)
Courtesy of the J. Paul Getty Museum.

30 • FRANK EUGENE (American, 1865–1936)
Frau Ludwig von Holwein, 1910 (or earlier)
Photogravure (from Camera Work, July 1910)
4¹³⁄₁₆ × 6¹⁵⁄₁₆ in.
Courtesy of the International Museum of Photography at
George Eastman House, Rochester, New York.

31 • HELEN M. BECHT (American)
Untitled, c. 1930
Gelatin printing-out paper
3⅜ × 6½ in.
Courtesy of Priscilla J. Barclay and Kenneth C. Burkhart.

32 • JAMES VAN DER ZEE (American, 1886–1983)
Smart Cat, New York City, 1931
Gelatin silver print
7 × 10 in.
Courtesy of Donna Mussenden-Van Der Zee.

33 • RICHARD POLAK (Dutch, 1870–1957)
Merry Company, 1913
Gum platinum print
9 × 6½ in.
Courtesy of the Royal Photographic Society, Bath,
England.

34 • EUGÈNE ATGET (French, 1857–1927)
Cour de Rouen, 1915
Albumen silver print
9⅜ × 7 in.
Collection the Museum of Modern Art, New York, Abbott-
Levy Collection, Partial gift of Shirley C. Burden.

35 • ARNOLD GENTHE (American, b. Germany; 1869–1942)
French Quarter Patio with Cat (Boss of the Fish Dealer's Court), c. 1925
Platinum print
12³⁄₁₆ × 9⁷⁄₁₆ in.
Courtesy of the New Orleans Museum of Art, City of New Orleans Capital Fund.

36 • ANDRÉ KERTÉSZ (American, b. Hungary; 1894–1986)
Rue Bourgeois, 1931
Gelatin silver print
7¾ × 9⅝ in.
Courtesy of the Estate of André Kertész.

37 • ANDRÉ KERTÉSZ (American, b. Hungary; 1894–1986)
Paris, 1928
Gelatin silver print
7⅝ × 9⅜ in.
Courtesy of the Estate of André Kertész.

38 • HARRY WARNECKE (American, 1900–1984)
Cat Crossing the Street in Traffic, 1925
Gelatin silver print
Courtesy of the *New York Daily News*.

39 • Photographer unknown (American)
Animal Rescue League, Boston, Massachusetts, c. 1940
Gelatin silver print
14 × 11 in.
Courtesy of Rodger Kingston.

40 • CARL MYDANS (American, b. 1907)
Father and Son Wear Their Hats to Pose in Their Cincinnati Tenement, 1936
Gelatin silver print
8 × 10 in.
Courtesy of the Library of Congress.

41 • WALKER EVANS (American, 1903–1975)
Storefront and Signs, Beaufort, South Carolina, March 1936
Gelatin silver print
8 × 10 in.
Courtesy of the Library of Congress.

42 • HELEN LEVITT (American, b. 1918)
New York, c. 1940
Gelatin silver print
8⅝ × 10¾ in.
Courtesy of the photographer and the Laurence Miller Gallery, New York.

43 • HELEN LEVITT (American, b. 1918)
New York, c. 1945
Gelatin silver print
10¾ × 8⅝ in.
Courtesy of the photographer and the Laurence Miller Gallery, New York.

44 • WEEGEE [ARTHUR FELLIG] (American, 1898–1968)
Tenement Penthouse, 1940
Gelatin silver print
15½ × 13 in.
Courtesy of Wilma Wilcox, Curator, the Weegee Collection.

45 • MARION POST WOLCOTT (American, b. 1910)
A Fireplace in an Old Mud Hut Which Was Built and Is Still Lived In by a French-mulatto Family, near the John Henry Plantation, Melrose, Louisiana, 1940
Gelatin silver print
10 × 8 in.
Courtesy of the Library of Congress.

46 • WEEGEE [ARTHUR FELLIG] (American, 1898–1968)
Lady and Cat, c. 1940
Gelatin silver print
13⅝ × 10½ in.
Courtesy of Wilma Wilcox, Curator, the Weegee Collection.

47 • JEAN-PHILIPPE CHARBONNIER (French, b. 1921)
The Cat, Lenoir-Jousserand Old Folks' Home, Saint Mandé, 1959
Gelatin silver print
11¹³⁄₁₆ × 15¾ in.
Courtesy of the photographer and of Françoise Mommessin, Agence Photographique TOP, Paris.

48 • RUTH ORKIN (American, 1921–1985)
Old Women Feeding Cats, Rome, 1951
Gelatin silver print
7 × 9½ in.
Courtesy of Mary Engel for the Estate of Ruth Orkin.
Copyright © 1981 Ruth Orkin.

49 • DAN WEINER (American, 1919–1959)
Beta Weiner, Shelter Island, 1953
Gelatin silver print
8 × 10 in.
Courtesy of Sandra Weiner.

50 • SANDRA WEINER (American, b. 1921)
83rd Street and East End Avenue, New York City, 1951
Gelatin silver print
7⁷⁄₁₆ × 7⅜ in.
Courtesy of the photographer.

51 • HENRI CARTIER-BRESSON (French, b. 1908)
Shop Window, Lille (Nord), n.d.
Gelatin silver print
6⅝ × 9⅞ in.
Courtesy of Magnum Photos, Inc.

52 • JOSEF KOUDELKA (Czech, b. 1938)
Untitled, n.d.
Gelatin silver print
8¼ × 9¾ in.
Courtesy of Magnum Photos, Inc.

53 • DONALD McCULLIN (British, b. 1935)
Snowy, the Mouse Man, Oakington, Cambridgeshire, n.d.
Gelatin silver print
9⅟16 × 13⁷⁄16 in.
Courtesy of Magnum Photos, Inc.

54 • ELLIOTT ERWITT (American; b. France, 1928)
Untitled, n.d.
Gelatin silver print
7½ × 8⅜ in.
Courtesy of Magnum Photos, Inc.

55 • LÁSZLÓ MOHOLY-NAGY (Hungarian, 1895–1946)
Untitled (Negative Cat), c. 1926
Gelatin silver print
11³⁄16 × 9⅟16 in.
Collection of the Art Institute of Chicago, Julien Levy
Collection and Special Photography Fund, 1979.82.
Copyright © 1989 Art Institute of Chicago.
All rights reserved.

56 • OSCAR NERLINGER (German, 1893–1969)
The Cat, 1930
Photogram
4¾ × 5¹¹⁄16 in.
Courtesy of the Sander Gallery, New York.

57 • AUGUST SANDER (German, 1876–1964)
Corner of the Finishing Room at Cologne with Portraits
of Franz Wilhelm Seiwert and Heinrich Hoerle, April 1943
Gelatin silver print
9⁷⁄16 × 7⅟16 in.
Courtesy of the August Sander Archive. Copyright © 1990
August Sander Archive.

58 • EDWARD WESTON (American, 1886–1958)
Cats on Woodbox, 1944
Gelatin silver print
7⅞ × 9⅝ in.
Collection of the Art Institute of Chicago, Gift of Max
McGraw, 1959.835. Courtesy of the Art Institute of
Chicago. Copyright © 1981 Arizona Board of Regents,
Center for Creative Photography.

59 • EDWARD WESTON (American, 1886–1958)
Cats on Steps, 1944
Gelatin silver print
8¹⁵⁄16 × 6¾ in.
Collection of the Art Institute of Chicago, Gift of Max
McGraw, 1959.834. Courtesy of the Art Institute of
Chicago. Copyright © 1981 Arizona Board of Regents,
Center for Creative Photography.

60 • IMOGEN CUNNINGHAM (American, 1883–1976)
Edward Weston, Photographer, with His Cats, 1945
Gelatin silver print
6 × 6 in.
Courtesy of Imogen Cunningham Trust. Copyright © 1970
Imogen Cunningham Trust.

61 • LESLIE GILL (American, 1908–1958)
Gentilini, Painter, and Daughter, Rome, Italy, 1947
Gelatin silver print
16 × 13¼ in.
Courtesy of Frances McLaughlin-Gill.

62 • BARBARA MORGAN (American, b. 1900)
Tossed Cats (Strobe), 1942
Gelatin silver print
10½ × 13½ in.
Courtesy of the photographer.

63 • K. J. GERMESHAUSEN (American, active Massachusetts)
"Plaster" Turns Over and Makes a Four-Point Landing,
New England Cat Club Show, December, 1948
Gelatin silver print, multiflash picture at five pictures
per second
10 × 8 in.
Courtesy of the Bettmann Archive.

64 • PHILIPPE HALSMAN (American, b. Latvia; 1906–1979)
Dalí Atomicus, 1948
Gelatin silver print
7½ × 9⁷⁄16 in.
Courtesy of Yvonne Halsman. Copyright © 1990
Yvonne Halsman.

65 • MARTHA SWOPE (American)
George Balanchine and Mourka, 1965
Gelatin silver print
10 × 8 in.
Courtesy of the photographer. Copyright © 1965
Martha Swope.

66 • PAUL FRIPP (British, 1890–1945)
By the Fire, 1932
Bromide
7⅜ × 8⅝ in.
Courtesy of the Royal Photographic Society,
Bath, England.

67 • ANDRÉ KERTÉSZ (American, b. Hungary; 1894–1986)
Studio Cat, 1927
Gelatin silver contact print
3⁹⁄16 × 3⅛ in.
Courtesy of the Estate of André Kertész.

68 • EDWARD STEICHEN (American, b. Luxembourg;
1879–1973)
Noel Coward, 1932
Montaged gelatin silver print
16⁹⁄16 × 13⁷⁄16 in.

Collection of the International Museum of Photography at George Eastman House, Bequest of Edward Steichen by direction of Joanna T. Steichen. Courtesy of Joanna T. Steichen and the Julian Bach Literary Agency.

69 • WANDA WULZ (Italian, 1903–1984)
My Cat and I, 1932
Gelatin silver print
11 9/16 × 9 1/4 in.
Courtesy of The Metropolitan Museum of Art, Ford Motor Company Collection, 1987.110.123. Gift of the Ford Motor Company and John C. Waddell, 1987.

70 • MADAME D'ORA [DORA KALLMUS] (Austrian, 1881–1963)
Tsugouharu Foujita, c. 1935
Gelatin silver print
Courtesy of Museum of Art and Industry, Hamburg.

71 • LOUISE DAHL-WOLFE (American, 1895–1989)
Mary Jane Russell in Gown Embroidered with Beads, Paris, 1951
Gelatin silver print
14 × 11 in.
Courtesy of Christopher Green, the Louise Dahl-Wolfe Trust.

72 • LOUISE DAHL-WOLFE (American, 1895–1989)
Mary Jane Russell on Leopard Sofa, Paris, 1951
Gelatin silver print
11 × 14 in.
Courtesy of Christopher Green, the Louise Dahl-Wolfe Trust.

73 • RICHARD AVEDON (American, b. 1923)
Suzy Parker and China Machado with Robin Tattersall and Dr. Reginald Kernan,
Evening Dresses by Balmain and Patou, La Pagode d'Or, Paris, January 1959
Gelatin silver print
18 1/4 × 21 1/2 in.
Courtesy of the photographer. Copyright © 1959 by Richard Avedon. All rights reserved.

74 • SIR CECIL BEATON (British, 1904–1980)
Mrs J. J. Astor's Cat, August 1972
Gelatin silver print
Courtesy of Sotheby's London.

75 • ELLIOTT ERWITT (American; b. France, 1928)
Cat Show, New York City, n.d.
Gelatin silver print
10 1/4 × 11 7/8 in.
Courtesy of Magnum Photos, Inc.

76 • JILL FREEDMAN (American)
Gladys and Shorty, 1971
Gelatin silver print
20 × 16 in.
Courtesy of the photographer.

77 • JEAN-PHILIPPE CHARBONNIER (French, b. 1921)
Sunday in Spring, Paris, 1970
Gelatin silver print
15 3/4 × 11 13/16 in.
Courtesy of the photographer and of Francoise Mommessin, Agence Photographique TOP, Paris.

78 • MARC RIBOUD (French, b. 1923)
Nude in Prague, 1981
Gelatin silver print
9 1/2 × 6 1/4 in.
Courtesy of the photographer.

79 • SIR CECIL BEATON (British, 1904–1980)
Antonia, Lady Aberconway's Cat at Bodnant,
May 24, 1960
Gelatin silver print
Courtesy of Sotheby's London.

80 • ELAINE MAYES (American, b. 1938)
Leland under the Hedge, Florence, Massachusetts, 1976
Gelatin silver print
7 3/4 × 11 1/2 in.
Courtesy of the photographer.

81 • ELAINE MAYES (American, b. 1938)
Tweede, 1973
Gelatin silver print
5 5/8 × 8 1/2 in.
Courtesy of the photographer.

82 • ELAINE MAYES (American, b. 1938)
Red on the Table, Florence, Massachusetts, 1973
Gelatin silver print
11 3/4 × 8 in.
Courtesy of the photographer.

83 • EDOUARD BOUBAT (French, b. 1923)
Amish Farm, Pennsylvania, U.S.A., 1979
Gelatin silver print
15 3/4 × 11 13/16 in.
Courtesy of the photographer and of Francoise Mommessin, Agence Photographique TOP, Paris.

84 • ARTHUR FREED (American, b. 1936)
Untitled, Israel, 1982
Gelatin silver print
11 × 14 in.
Courtesy of the photographer. Copyright © 1982 Arthur Freed.

85 • ARTHUR FREED (American, b. 1936)
Untitled, Israel, 1982
Gelatin silver print
11 × 14 in.
Courtesy of the photographer. Copyright © 1982 Arthur Freed.

86 • JOHN KIMMICH (American, b. 1950)
Gardens of the Alhambra, Granada, Spain, 1988
Gelatin silver print
14 × 11 in.
Courtesy of the photographer. Copyright © 1988
John Kimmich.

87 • LEE FRIEDLANDER (American, b. 1934)
Houston, 1977
Gelatin silver print
11 × 14 in.
Courtesy of the photographer.

88 • LEE FRIEDLANDER (American, b. 1934)
Martha Ryther, New City, New York, 1976
Gelatin silver print
11 × 14 in.
Courtesy of the photographer.

89 • LEE FRIEDLANDER (American, b. 1934)
Bob Blechman, New York City, 1968
Gelatin silver print
11 × 14 in.
Courtesy of the photographer.

90 • ANNE NOGGLE (American, b. 1922)
Karen, 1978
Gelatin silver print
14 × 17 in.
Courtesy of the photographer.

91 • ANNE NOGGLE (American, b. 1922)
Morris, 1976
Gelatin silver print
17 × 14 in.
Courtesy of the photographer.

92 • NICHOLAS NIXON (American, b. 1947)
Kinnaird Street, Cambridge, 1981
Gelatin silver contact print
8 × 10 in.
Courtesy of the photographer. Copyright © 1981
Nicholas Nixon.

93 • SAGE SOHIER (American, b. 1954)
Brookline, Massachusetts, 1986
Gelatin silver print
14 × 17 in.
Courtesy of the photographer. Copyright © 1986
Sage Sohier.

94 • DUANE MICHALS (American, b. 1932)
Homage to Cavafy, 1978
Gelatin silver print
5 × 7 in.
Courtesy of the photographer and the Sidney Janis
Gallery, New York. Copyright © 1979 Duane Michals.

95 • TONY MENDOZA (American; b. Cuba, 1941)
Untitled (from the *Ernie* series), 1983
Gelatin silver print
16 × 20 in.
Courtesy of the photographer and the Witkin Gallery,
New York.

96 • TONY MENDOZA (American; b. Cuba, 1941)
Untitled (from the *Ernie* series), 1983
Gelatin silver print
16 × 20 in.
Courtesy of the photographer and the Witkin Gallery,
New York.

97 • TONY MENDOZA (American; b. Cuba, 1941)
Untitled (from the *Ernie* series), 1983
Gelatin silver print
16 × 20 in.
Courtesy of the photographer and the Witkin Gallery,
New York.

98 • DAVID AVISON (American, b. 1937)
Puck, Wilmette, Illinois, 1983
Gelatin silver print
6 × 19 in.
Courtesy of the photographer.

99 • JAN GROOVER (American, b. 1943)
Untitled, 1982
Platinum-palladium print
10⅜ × 13¼ in.
Courtesy of the Robert Miller Gallery. Copyright © 1982
Jan Groover.

100 • JAN GROOVER (American, b. 1943)
Untitled, 1985
Gelatin silver print
15 × 11½ in.
Courtesy of the Robert Miller Gallery. Copyright © 1985
Jan Groover.

101 • MARCUS LEATHERDALE (American; b. Canada, 1952)
The Familiar, 1986
Gelatin silver print
9½ × 7¼ in.
Courtesy of the photographer.

102 • Photographer unknown
Cat with Camera, n.d.
Gelatin silver print
9⅛ × 7⅜ in.
Courtesy of the Bettmann Archive.

103 • Photographer unknown
A Businesslike Tabby, c. 1925–1930
Gelatin silver print
10 × 8 in.
Courtesy of the Bettmann Archive.

ACKNOWLEDGMENTS

My more whimsical ideas about cats and photography date back to a class given in the mid 1970s by William Jenkins, then curator of twentieth-century photography at the International Museum of Photography at George Eastman House in Rochester, New York. With Bill's help we students concocted the history of "hoptography," in which we showed photography to be the work of rabbits. The evidence was convincing: the invention of photography, after all, is credited to "Daghare," not to the unsuitably named Fox Talbot, and hoptography's distinguished practitioners include "Berenice Rabbit," "Hopper Evans," "Brert Weston," Bunny Yaeger, Chauncey Hare, and "Thomas Burrow," to name just a few.

It has taken me more than a decade to rebut this worthy theory with my essay on "catography." If further proof is needed, one need only look to Lee Friedlander's recent catalogue and exhibition *Like a One-Eyed Cat.*

Thanks are also due Robert Sobieszek, curator of nineteenth-century photography at George Eastman House, who during that same period presented a memorable lecture on the ideas of the photographer in the window, the *flâneur*, and other modi operandi that distinguish photographers from visual artists in other media. However, the responsibility for applying his ideas to the pictures of cats and to the catlike photographers showcased in this book is entirely my own. Bob's special interest is sheep — as symbols in Victorian Christian allegories.

Ruth Silverman, whose delightful book *The Dog Observed: Photographs, 1844 to 1983* prompted this project, was most generous with her time and suggestions. As a "dog person," she chose not to pursue cats, thus making way for me. I would say this volume is a "copycat" book except that anyone familiar with cats knows they don't copy anything or anybody. Other picture books that I found to be of help were *The Dog in Art: Rococo to Postmodernism* by Robert Rosenblum; *The Metropolitan Cat* by the staff of the Metropolitan Museum of Art; *The Painted Cat* by Elisabeth Foucart-Walter and Pierre Rosenberg; and *The Animal in Photography*, a catalogue published by the Photographers' Gallery in London. I spent many enjoyable hours curled up with the illustrated books about cats edited by Jean-Claude Suarès, particularly *The Indispensable Cat.*

Of the hundreds of books on the subject of cats, I turned most often to *The Tiger in the House* by Carl Van Vechten. Other valuable and amusing sources were *The Velvet Paw* by Jean Conger; *The Everlasting Cat* by Mildred Kirk; *Nine Lives: The Folklore of Cats* by Katharine Briggs; *The Cat's Pajamas: A Charming and Clever Compendium of Feline Trivia* by Leonore Fleischer; the massive *Cat Catalog* edited by Judy Fireman; and the smart and charming new book *Secrets of the Cat* by Barbara Holland. As most lovers of cats already know, Colette, M. F. K. Fisher, and Doris Lessing have written perceptively and elegantly about their cats and those of others.

Talks with my friends and colleagues Peter Berg, Ken Burkhart, Roberta DeGolyer, Jim Dow, Barbara Erdman, Bill Ewing, David Freund, Chris Green, William Innes Homer, Anne Hoy, Jain Kelly, John Kimmich, Rodger Kingston, Tony Mendoza, Christopher Phillips, Toby Quitslund, Gerd Sander, Robert Shlaer, and Anna Winand prompted many ideas and led to the discovery of unusual and unknown photographs and obscure facts. On a trip to Egypt with India Supera, Rachel Margolin,

and Abd el Hakim in December 1987, I had a unique opportunity to worship the feline gods Bastet and Sekhmet.

It was highly rewarding to discover how many art photographers welcomed the opportunity to publish their pictures of cats in a serious photographic book. Uncertain of a proper curatorial response, many had hidden the pictures away for years. I regret that it was not possible to include any of the fine color photographs of cats produced in the 1970s and 1980s by William Eggleston, David Hockney, Len Jenshel, Sandy Skoglund, William Wegman, and many others.

Those who offered special help at museums and libraries include Nancy Barrett at the New Orleans Museum of Art; David Travis, Russ Harris, and Lynn Herbert at the Art Institute of Chicago; Rod Slemmons of the Seattle Art Museum; Barbara Galasso and Patricia Musolf of the International Museum of Photography at George Eastman House; Peter Galassi and Thomas Grischkowsky at the Museum of Modern Art, New York; Deborah Ireland at the Royal Photographic Society, Bath, England; Paula Stewart of the Amon Carter Museum; Craig C. Garcia of the Whatcom Museum of History and Art; Jan Adlmann of the Vassar College Art Gallery; and Nancy Baird of the Kentucky Library.

At the agencies, galleries, and magazines, I was assisted by Françoise Mommesin of Agence Photographique TOP; Tina Tryforos and Laura Straus of Magnum Photos, Inc.; Susan Arthur of the Robert Miller Gallery; Vicki Harris of the Laurence Miller Gallery; Darby Harper of the Bettmann Archive; Lydia Cresswell Jones of Sotheby's London; Kate Schlessinger at *Vogue*; Shelley Dowell of Richard Avedon Studio; Christopher Green of the Louise Dahl-Wolfe Trust; Robert Gurbo of the Estate of André Kertész; and Larry Gottheim, a dealer of fine early photographs who is based in Binghamton, New York.

Terry Reece Hackford, senior editor at Bulfinch Press, has been a guiding light throughout this project. Her confidence, cheer, humor, and competence have simultaneously eased my task and inspired me. This book also benefited from the suggestions and corrections of copyeditor Robin Jacobson, from the elegant design of Martine Bruel, and from the skilled editorial assistance of Dana Goodall. Special thanks also go to my agent, Lynn Franklin, of Lynn Franklin Associates in New York City, for urging me on and for helping me secure a contract with the best possible publisher.

During the past few years the care, faith, imagination, and inspiring examples of Keith I. Block, Mary Dunn, Eknath Easwaran, Yadi Flannery, Gabriel Halpern, Bill Jorden, Sri Kriyananda, Brooke Medicine Eagle, Susan Osborn, Bear Sahlfield, and Karen Teigeser directly affected me and indirectly influenced this book.

Most of all, I thank Bill Osborne for his ideas, wit, companionship, support, and love.

Without the welcome help of Isis and Siris Rumble-Thump (who sat on my keyboard, shuffled pages, flipped pictures, pulled out the telephone cord, and otherwise manifested unbounded aliveness and joy), this book would have been completed far sooner.

•103• Photographer unknown, *A Businesslike Tabby*, c. 1925–1930

Edited by Terry Reece Hackford and Dana Goodall
Copyedited by Robin Jacobson
Designed by Martine Bruel
Production coordinated by Amanda Freymann and Jennifer Kerns
Set in Garamond Book (ITC) by Hamilton Phototype
Separations, printing, and binding by Tien Wah Press Ltd.

7172